Franco Maria Ricci

Champalimaud
Foundation

For Christmas 2023 the Champalimaud Foundation is turning to the Royal Treasury of the Ajuda National Palace for its book, particularly the goldsmithery and jewellery collected by the Portuguese Court.

Science and technology are at the ancestral foundation of the discovery of metals, their melting and their practical application, from the most rudimentary utilitarian tools to goldsmithing and jewellery. From civilisations and cultures as distant and ancient as the Middle East, Aztecs, Mayans, Incas, Egypt and China, gold and silver pieces have been retrieved that served as adornment and gave a sign of power to those who owned them. Much later, India, Persia, the European royal houses and the wealthy bourgeoisie would follow this tradition in more elaborate formats: technology made it possible to set precious stones in gold, platinum and silver, and crowns, tiaras, necklaces, bracelets and rings were first conceived, signifying wealth, fuelling vanity, inspiring passion, satisfying whims, mending indiscretions. The rarer the stones, the higher the value, with diamonds at the top of this hierarchy, some of which would gain their own names and come to grace royal crowns, museums, the collection of the Emir of Qatar and even Elizabeth Taylor's neck. For its part, goldsmithing would follow suit and the dining rooms and churches of Europe, from Constantinople to Paris, from St. Petersburg to Lisbon, as well as temples from Japan to Cambodia, from Laos to Ceylon, would begin to glisten.

The Champalimaud Foundation's annual Christmas Book seeks to correlate the chosen theme with the core of the Foundation's Research Centre: Knowledge, Science, the Brain and how it works. In this vein, previous years have seen the publication of works on Garcia de Orta and the Cabinets of Curiosities (Kunstkammer), the Jerónimos Monastery, Pedro Hispano's Treatise on the Eyes, Alexandre Rodrigues Ferreira's work on Natural History, the Convent of Christ in Tomar, and part of the collection of the National Museum of Ancient Art.

From the end of the 18th century until the end of the monarchy, Portugal went through numerous upheavals, the biggest of which was the Court's flight to Brazil in 1807. Naturally, objects of great historical and heritage value that had been saved from the 1755 earthquake were lost, including paintings, tapestries, porcelain and goldsmithery. However, it was possible to salvage the Germain service tableware set and the set of jewels that the Ajuda National Palace has managed to gather and is now displaying, and which the Champalimaud Foundation is proud to feature in this edition of its Christmas Book.

Champalimaud Foundation

Braganza's
CROWN JEWELS

Texts by
José Alberto Ribeiro
Giuseppe Scaraffia

Foreword by the curators
Hugo Xavier,
Inés Líbano Monteiro,
João Júlio Rumsey Teixeira,
Manuela Santana,
Teresa Maranhas

Franco Maria Ricci

Contents

Acknowledgements

Hugo Xavier;
Inês Líbano Monteiro;
João Júlio Rumsey Teixeira;
Manuela Santana;
Rui Galopim de Carvalho;
Tânia Olim;
Teresa Maranhas;
Nuno Vale;
João Carlos dos Santos

Palácio
Nacional
da Ajuda

Editorial project
Edoardo Pepino

Art Direction
Laura Casalis

Editorial Coordination
Andrew Tasker
Orsola Bontempi

Graphic Design
Laura Fava

Translation
Jeremy Carden for Il Nuovo Traduttore
Lettarario, Florence
Mick Greer

Editing
Mick Greer
Graça Margarido

Printed by
Grafiche Step, Parma

Photography
Album / Alamy Foto Stock: p. 81
ARTGEN / Alamy Foto Stock: copertina; 63
Bridgeman Images: pp. 65; 71; 94; 110
© Christie's Images / Bridgeman Images: pp. 48/49
Consejería de Cultura de la Junta de Andalucía / Museo de Bellas Artes de Cordoba: p. 44
José Eduardo Cunha: p. 106
A. Dagli Orti/Scala, Firenze: p. 78
DeAgostini Picture Library/Scala, Firenze: p. 75
©DGPC/ADF Manuel Farinha: pp. 38; 40
©DGPC/ADF Luísa Oliveira: pp. 13; 14; 42; 62; 68; 69; 77; 83; 90-92; 96; 98-105; 107; 111; 112; 120-123
©DGPC/ADF Manuel Silveira Ramos: pp. 41; 117; 119
©DGPC/ADF João Silveira Ramos: pp. 36; 39; 67
©DGPC/ADF Henrique Ruas: p. 53
©DGPC/ADF José Paulo Ruas: pp. 29-31; 70; 73
incamerastock / Alamy Foto Stock: p. 113
Massimo Listri: pp. 2-10; 17-27; 32-35; 44; 59; 60; 86; 87; 115; 116; 125-127; 130-138
©MiC – DRM Piemonte: p. 50
Niday Picture Library / Alamy Foto Stock: p. 97
José Pessoa: p. 56; 128
Royal Collection Trust / © His Majesty King Carlos III 2023: pp. 43; 82

Page 2 and 4/5
View of the Champalimaud Foundation in Lisbon, designed by Carlos Correa (1930-2015).

Page 6
Royal mantle used in the proclamation of King João VI
Rio de Janeiro, Brazil, 1817
Silk, silver, gold, glass beads
291 x 147 cm, inv. 2420

Pages 8/9
Entrance to the Royal Treasure Museum, Ajuda National Palace, Lisbon

Page 10
Tall-footed salver
Portugal (?), 16th century (?)
Insc.: "RT N° 7"; "M" cursive
Silver-gilt
5.8 x 32 cm, inv. 4810
Shield with the Portuguese royal arms, flanked by mantling and topped by an open royal crown

Page 13
Mellerio dits Meller (attrib.)
Bracelet with miniature of Princess Clémentine of Orléans, sister-in-law of Maria II
Paris, France, 2nd quarter of the 19th century
Gold, painted ivory, glass
4.2 x 25.5 x 0.9 cm, inv. 2162

All the works illustrated in this book are on display at the National Palace of Ajuda, unless specified otherwise.

The Royal Strongbox
Royal Treasure Museum

Recovered treasure

by Hugo Xavier, Inês Líbano Monteiro, João Júlio Rumsey Teixeira, Manuela Santana, Teresa Maranhas

The idea of creating a space in the Ajuda National Palace (PNA) to display the treasures of the Portuguese royal collections is not new. King Luís I, who chose this palace as his official residence on ascending the throne in 1861, is credited with adapting a room to display some of the Crown's most precious jewellery and personal property, along with other historically and artistically significant objects, together with an important numismatic collection. Located on the main floor of the building, next to the painting gallery that opened in 1869, this museum centre had a curator and was open to the public on Sundays, just like the neighbouring Pinacoteca.

The Republic was established in 1910, but it took until 1954 for the royal treasures to be collected and made available again, with the creation of a vault on the palace's ground floor to display not only silver but also, and for the first time, jewellery. The vault contents were made up of pieces from three different sources: the old Crown jewellery, some privately owned precious objects that remained in Queen Maria Pia's quarters, and pieces acquired by the State from the heirs of King Miguel and his sister, Ana de Jesus Maria, in 1943. That same year, the Catalogue of Crown Jewels and Silverware was published, organised by José Rosas Jr., who had been entrusted with restoring the jewels.

In 1991, the first major exhibition took place, showcasing the Crown's jewellery and goldsmithery pieces alongside those from the royal family's former private collections. Organised at and by the PNA, it had a profound impact on the Portuguese cultural agenda that year and also triggered a series of (unrealised) projects for the permanent presentation of the collection. The exhibition and its catalogue led to a considerable advance in research into the Portuguese royal collections and gave rise to unprecedented international interest in various pieces that led, over the following years, to their being shown in various exhibitions abroad.

The Royal Treasure Museum, which has been open to the public since 1st June 2023, will finally put a large number of the former Portuguese monarchy's possessions on permanent display. These will be both works belonging to the Crown and from the private collections of various royal family members. The new museum's programme, conceived after years of meticulous work by the present curator and other consultants, seeks to highlight the artistic and symbolic value of the pieces, explaining their role in the service of the monarchy during the ceremonial functions representing royal power, in terms of devotion, diplomatic activity and the field of 19th century collecting.

The exhibition is divided into eleven sections. The first is called *Gold and Diamonds from Brazil* and presents rough specimens symbolising two of the Crown's important monopolies, as well as two of the essential raw materials for the goldsmithery making up a large part of the Treasure. As a natural destination for extracted metals, coinage is represented in the second section, which displays a selection of the *Coins and Medals of the Crown*.

The third section, *Jewels*, displays the

PNA's collection of pieces of jewellery belonging to the Crown, i.e. the State. There is also jewellery from the private collections of different royal family members, including an important and diverse set of ceremonial arms, most of which were acquired from King Miguel's estate.

The section dedicated to the *Orders of Knighthood and Orders of Merit* brings together a collection unparalleled at national level: a centuries-old testimony to the intense international relations of the Portuguese court and the historical importance of these instruments of sovereignty and diplomacy. Bringing together some of the most important and symbolic pieces in the entire treasure, the fifth section presents the *Royal Insignia*. Used at coronations, as well as other ceremonies, such as the opening of parliament - under constitutional rule - some of the Crown's most symbolic and valuable jewellery is displayed here. There are the rich decorations of the Three Military Orders - Christ, Aviz and Santiago -, the royal crown, two sceptres, and the two surviving cloaks, of the many that served Portuguese monarchs throughout history.

The sixth section, *The Crown's Silver*, is dedicated to silver-gilt and richly crafted objects for civil use from different production centres, especially an outstanding set of 16th century Portuguese salvers and plates. Part of the royal silver, they were presented to the public for the first time as such, with the highlight being the set reserved, since the end of the 18th century, for the Crown's major public ceremonies. This is followed by the seventh section, which exhibits Ferdinand II's *Private Collections*, together with those of his son, Luís I. There are also other fine civil use pieces, brought together through the 1800s' collecting spirit, which are distinguished from the other exhibits. Diplomacy has played a decisive role in relations between states over the centuries. The eighth section, *Diplomatic Gifts*, focuses on this aspect, with the two papal golden roses being prestigious examples. Religious ceremonies are evoked in the next section, *The Royal Chapel*, with a selection of liturgical implements and vestments from the many that were once part of the Crown's patrimony.

The tenth section is dedicated to *The Royal Table*, featuring the Germain Silver Table Service, named after the goldsmith, François-Thomas Germain, it was commissioned from after the 1755 earthquake. A benchmark of 18th century French goldsmithery, it was scenographically designed to be arranged according to symmetrical and codified table plans that distinguished the great tables of the mid-18th century. This justifies the current exhibition option to have its various pieces in dialogue with each other. The last section, *The Treasure's Travels*, highlights the mobility of the treasure that was usually with the king: its glory and the vicissitudes that involved risks of dispersal and loss. Some of the cases and safes used for packaging and transport are also on display.

Crown, Royal House and Family

More than 110 years after the establishment of the Republic, some semantic nuances when dealing with the former royal patrimony need to be clarified. During the monarchical regime, the Crown symbolised the nation, i.e. the Crown could mean the kingdom or the state. The aristocratic system of the *ancien régime* organised the family and hereditary patrimony into houses, which functioned as a managing and providing entity for the members of the family. They also served as a social framework and material network for the activity (or inactivity) of their members. The various houses had different positions at court, enjoying privileges and tenures granted by the Crown, whose government was entrusted to the most powerful one: the royal house. Assuming hereditary governance of the kingdom, the royal house was also made up of the various members of the royal family. After the restoration of independence in 1640, the House of Braganza was chosen to take over the Portuguese Crown. The Braganzas thus united their patrimony with that of the Crown without merging it - until 1910, the *Morgado da Cruz*, or House of Braganza, had its own capital - a legal exception to the extinction of the *morgados*, which served as a complement to the Crown's income.

It is clear that the Crown transcended the notion of a dynasty or royal house. As a symbol of the country, it not only owned the immateriality of national representation, but also the kingdom's greatest material heritage, which naturally included vast art collections, in which jewellery played an important role.

Until 1820, the Crown Treasure was seen as an integral part of the kingdom's, being not only at the service of the royals and official representation, but also available to meet funding needs, as occurred, for example, during the Restoration Wars or in the years leading up to the Peninsular War. After the liberal revolution, the assets of the royal house were separated into those identified as belonging to the nation (the Crown) and those considered the private property of members of the royal family. From then on, the Crown's jewellery collections were clearly defined, with the Royal Treasure remaining the place to safeguard the jewels, silverware and other precious items of the Crown: collections of goldsmithery, numismatics, jewellery, diamonds, textiles and other artworks. Despite this, there were important additions to the Treasure during the constitutional period, as well as some disposals, including the sale of almost all of the Crown's diamond fund: a process that research has clarified.

The largest addition took place in 1845 with Maria II, through the intervention of her husband, Ferdinand II, and consisted of 14 pieces. These were mostly liturgical implements from the male convents abolished by Liberalism, which were then collected at the Imprensa Nacional (National Press) in Lisbon. Of remarkable artistic and historical importance, they formed part of the group of implements attached to the Royal Chapel, which became known as the Sacred Treasure of the Royal House.

Page 25

Arcangelo Fioravanti (attrib., act. 1670-1696)
Jug
Rome, Italy, last quarter of the 17th century
Insc.: "RT N° 14"
Silver-gilt
29 x 32.5 x 15.5 cm, inv. 4800

Pages 26/27

Philipp Kusel (17th century)
Serving Tray
Augsburg, Germany, 1692-1697
Insc.: "I"; "M"
Silver, silver gilt
2.5 x 48.5 x 56.4 cm, inv. 4379

Vicissitudes and Dispersal

The royal patrimony's chronicles and countless inventories bear witness to extensive wealth, which have sadly disappeared in the many vicissitudes marking Portugal's history. We need only go back to the disaster of Alcácer Quibir (1578) to find one of the moments when the Treasure was most impoverished. This was followed by the 60 years of Iberian union and the consequent Restoration Wars (1640-1668), financed in part by the Crown Treasure and the House of Braganza. After an important period of wealth and replenishment, the catastrophe of the earthquake/tsunami/fire of 1755 swallowed up the Paço da Ribeira with 250 years of history and a large part of the royal collections in one day.

José I and his daughter, Maria I, managed to recover a significant amount of the royal collection, but it suffered another major setback in 1794 when the Ajuda Royal Wooden Palace burned down. Shipments of gold and, in this period, diamonds especially, contributed to the rapid decision to build the new palace which, like the accumulation of new wealth in the Treasure, was interrupted by the royal family's departure for Brazil in 1808. Although more organised than some historians have led us to believe, the departure for Brazil was a milestone in the Royal Treasure's partial dispersal, especially as part of it did not return with the king in 1821, but remained in the service of the prince regent, Pedro. His subsequent political paths included the independence of Brazil (1822), of which he was the 1st Constitutional Emperor, and his being proclaimed King of Portugal in 1826. His abdication, in favour of his daughter, took him to Europe in 1831, along with the above mentioned part of the Treasure. It was deposited in the Bank of London, while he joined the Liberals and came to Portugal to defend his daughter's succession to the throne. Some of these assets, such as pieces of the Germain Service, were part of the inheritance shared at his death in 1834 and were no longer part of the Treasure. The 1828-1834 civil war consumed considerable financial resources, which was also reflected in the Crown's assets.

As mentioned above, the years of constitutional monarchy, in which the balance of public finances was repeatedly problematic, also meant losses in the Treasure. A public loan of 1,000 escudos, financed from the Crown's diamond fund, was approved by Pedro V in 1859, leading not only to the trading of what remained of the Secret Reserve created by King José in 1760, but also to the removal and sale of diamonds from some jewellery, such as José I's walking stick handle.

During the 76 years of constitutional monarchy, the Treasure remained at the service of the royal family, although there was a clear separation between the Crown's assets and those acquired privately by members of the family, paid for, naturally, from their own funds. This was the manner in which Ferdinand II and Luís I personally amassed an extremely important set of jewellery dating from the 16th to 19th century: collections that attracted international interest from the 1860s onwards.

The disadvantage of these works being privately owned was that they could be subject to disposal and division through inheritance which, with the death of Maria II (1853), inevitably led to their dispersal. However, it was during the 1870s and 1880s that this became more evident with the estates of the former Empress of Brazil and Duchess of Braganza, Amélie of Leuchtenberg (d. 1873), Isabel Maria of Braganza (d. 1876) and, most notably, Ferdinand II (d. 1885) being successively divided through inheritance. In addition to these, and now during the republican regime, the widow of Prince Afonso was given her part of the inheritance in 1925, which led to the dispersal of some very important pieces, such as the Braganza Brooch, now in the British Museum.

At the same time, Maria Pia's debts accumulated in the last years of her life.

This led to a large amount of her personal jewellery and some impressive silver pieces being sold in their entirety at auction in late July 1912. This was decided by the newly established Republic and in response to the second monarchist incursion in Minho.

Following the establishment of the Republic (1910), the Commission for the Inventory of the Royal Palaces was appointed to list its contents and separate Crown from private property, the latter to be returned to the exiled royal family. In this process, however, several private pieces were selected that were "of artistic, historical and archaeological value" which, for these reasons, were not returned. These items were integrated into the State's patrimony, as was the case with the important group of 16th century salvers, plates and water jugs collected by Ferdinand II.

Since the assets of the Crown already belonged to the State, this was a smooth transition and they are still part of national public collections today. A substantial part remained undivided, having moved at different times from the vault of the Necessidades Palace - where it was kept at the time of the 1910 Republican revolution - to the PNA. Others went to national museums, such as the National Museum of Ancient Art and the Soares dos Reis National Museum.

Research carried out by the project's curators and consultants has located pieces long been scattered throughout both national and foreign public and private collections, as a result of these and other circumstances. Highlights of the collection are a 16th century tall salver, or tazza, traditionally considered to represent "Vasco da Gama's fleet entering the harbour of Melinde [Malindi today] and being met by Fame in a chariot pulled by two elephants". This is according to the Portuguese and Spanish Ornamental Art Exhibition catalogue in 1882, when it was exhibited among other silver from the royal collections. In 1901, it was in the possession of the famous American collector, J.P. Morgan, and associated with the conquest of Tunis (1535). Since 1947, it has belonged to the Art Institute of Chicago.

Since the 1940s, the Portuguese state has been involved in buying some of the assets that have been widely scattered over the years. The jewellery purchases and other objects from King Miguel's estate were particularly important and, between 1834 and 1943, remained deposited at the Bank of Portugal. Other purchases, however, were made over the years. Although it is not possible to list them all, another outstanding item is the 1998 acquisition of the House of Musy brooch: a piece of jewellery sold at the 1912 auction that had been given to Maria Pia by her father, Vítor Emanuel II of Italy (p. 123). More recently, it was possible to acquire a silver centrepiece from the Veyrat Service and a Castellani pin (p. 125), both wedding presents from Queen Maria Pia and also sold at the 1912 auction.

Finally, during the building of the new museum, between 2019 and 2020, the State took the fortunate decision to acquire two important ceremonial arms from King Miguel's estate that were not part of the group of pieces acquired in 1943. Nevertheless, it is clear from the above that an important part of the former treasure remains divided among various public and private collections, both in Portugal and abroad. Moreover, this acquisition effort should be continued so that, in the future, the Royal Treasure Museum can mirror the country's history ever more faithfully.

Ajuda National Palace
Its History and Collections

→ ⊡
MUSEU
MUSEUM

The National Palace of Ajuda and the Royal Treasure Museum

by José Alberto Ribeiro

The Ajuda National Palace was built on the initiative of João VI (1767-1826) [PNA Inv.º 4115], who wished to create one of the largest palaces in the world and fill it with the riches of the Portuguese empire. Although unfinished until recently, it is still the main Portuguese palace in terms of the importance of its collections and the authenticity of its interiors. The various rooms are almost exactly as they were at the end of the monarchy in Portugal in 1910, taking us back to the original setting of private and political life that built Portugal's history. The palace treasures are varied, including collections from the royal family dating back to the 16th century featuring jewellery, paintings, ceramics, sculpture, textiles, furniture, glassware, photographs and decorative art objects that amount to more than 127,000 works.

The former royal residence is now a museum, while continuing to represent the nation, used for official ceremonies by the Presidency of the Republic and the Portuguese Government.

The royal palace in Lisbon (Paço da Ribeira) was destroyed in the 1755 earthquake. After this cataclysm, the Italian set designer João Carlos Bibiena was given the plan and designs for the new palace, this time in wood, in the Ajuda area. The *Real Barraca* (or the 'Royal Shack', as it became jokingly known) was richly decorated with tapestries and paintings, and provided with gardens, a chapel, a museum and a library. It burnt down one winter's night in 1794. The beautiful Botanical Gardens and the Tower of the Royal Chapel, which served temporarily as the cathedral, are all that remains of this 18th century complex. A palace of great dignity needed to be built in Lisbon and the foundation stone was laid on 9th November 1795, a palace dreamt up by the Prince Regent, João (VI).

It began as a project by the architect Manuel Caetano de Sousa (1738-1802), but his design was criticised by two neoclassically trained artists, the Italian Francisco Xavier Fabri (1761-1817) and José da Costa e Silva (1747-1819). In 1802, a decree from the Prince Regent gave the work to the aforementioned architects. José da Costa e Silva designed, but never carried out, the grand façade with a monumental staircase facing the River Tagus. This was intended to accommodate not only the Royal Household, but all the Secretariats of State and a large part of the public services of the time, in what was to be one of the largest palaces in Europe.

Interest in what was to be one of Lisbon's grandest buildings waned with the Peninsular War and the departure of the royal family and court for Brazil in 1807. This decreased further when, in 1812, the architect responsible was recalled to Rio de Janeiro and replaced by António Francisco Rosa. King João VI returned from Brazil in 1821 to see the work well behind schedule, forcing the sovereign to take up residence in the palaces of Bemposta and Queluz. With the king's death in 1826, Ajuda received the court of the regent *Infanta* Isabel Maria (1801-1876) and the tragic fate of the new palace, successor to the Paço da Ribeira and the 'Real Barraca', began. It also housed D. Carlota Joaquina (1775-1830) and her son, Miguel I (1802-1866), who was proclaimed king there in 1828. Work continued slowly, with a number of artistic projects never being completed. However, it wasn't until the coronation of Luís I (1838-1889) (p. 41) in 1861 and his marriage to Princess Maria Pia of Savoy (1847-1911) (p. 40) that renovation and remodelling created a new palace. As the young queen steadily applied her artistic sensibility to decorate and organise the new royal quarters, the deserted and inhospitable palace became

Not even the fervid imagination of Ovid, who was particularly well versed in metamorphoses, could have imagined that a palace might turn, as if in a spell, into a strongbox. Yet that was the destiny of the Palace of Ajuda in Lisbon, built in 1795 to house the riches of the Portuguese empire after the Ribeiro Palace was destroyed in the terrible earthquake of 1755 and its replacement, the so-called Real Barraca *or "royal tent", burnt down in a fire in 1794. Other architectural ghosts also surrounded it, what with the slow progress of work and projects that never saw the light of day. Thanks to the intervention of King Luís I, and, above all, his wife Maria Pia of Savoy, the palace finally assumed its present form, becoming a sophisticated noble residence with every type of artwork under its roof. Today the Palace of Ajuda is benignly open to those who want to explore its treasures. Perhaps the most dazzling of these is the Royal Treasure Room, of which the most beautiful and surprising items are illustrated in the pages of this book. Rearranged in 2022, it houses jewellery, coins and other precious objects that belonged to the House of Braganza, recounting not just the history of a dynasty and its members but also that of a nation.*

an authentic museum due to the rarity of its contents: refined and graceful whilst being welcoming and comfortable.

The new queen decorated Ajuda Palace as her home. She raised her two children there, choosing works from among the best in France, England, Italy, Belgium and Germany. From 1862, until the proclamation of the Republic, diverse national and foreign artists visited Ajuda, such as the architect Joaquim Possidónio da Silva (1806-1896); the sculptor and carver Leandro Braga (1839-1897) and the Italian painters and set designers G. Cinatti (1808-1879) and A. Rambois (c. 1810-1880), who renovated a large part of the royal quarters. Artists and especially portrait painters, such as Layraud (who painted the portraits of the royal family in 1874 and 1876) and Carolus Duran (in Portugal in 1880), left us exquisite works depicting the queen and her children, as did the Portuguese painters E. F. Condeixa (1857-1933), José Rodrigues (1828-1887) and José Malhoa (1855-1933).

A figure still unknown to many, the Italian Queen of Portugal, Maria Pia, was also mother and grandmother of kings. Her time in Portugal brought a refined taste that she applied to the Crown's palaces, especially Ajuda. She devoted special attention to this palace's decorative remodelling, taking into account new ideas of comfort and an up-to-date aesthetic sense, particularly associated with the French Second Empire.

The numerous acquisitions she made throughout her life endowed Ajuda with an artistic collection on a par with those of other European royal palaces.

The locals called her the 'Angel of Charity', because of her great generosity in giving alms and supporting those who came to her for help. In the words of a former servant, Vital Fontes, "she was too open-handed". Fontes also claimed that although she was shy, she "knew how to be queen" in the poise and ostentation she displayed in public. Always proud of being an Italian princess, she was also fully aware of the role and majesty that befitted the Queen of Portugal.

During the reigns of King Luís and Queen Maria Pia, Ajuda Palace was the stage for grandiose receptions, concerts, balls, parties, weddings, baptisms, along with princely and royal visits. Without Maria Pia's unstoppable desire to enhance the Ajuda Palace, we would not be able to boast one of the most remarkable palaces in Europe, in which the daily life of the Portuguese monarchs can still be felt.

The palace has various collections, particularly in the area of decorative arts. The sculpture collection includes around four hundred works in marble, bronze, wood, ivory and plaster, reflecting the Italian, Portuguese and French schools and names such as Sighinolfi, Santo Varni, Marchesi, Dupré, Frémiet, Calmels and José Simões de Almeida.

In terms of painting, there are more than 450 oils, besides around 880 works that include watercolours, drawings, pastels and sketchbooks. It began with pieces inherited from the royal collections, some of which were part of King Luís' Painting Gallery. The collection offers a wide range of themes, with a particular focus on aulic painting, featuring painters from Portugal and various European schools, especially from the 18th and 19th centuries. Within this collection are to be found names such as Sequeira, Malhoa, Krumholz, Delerive, Gordigiani, El Greco, Moroni, Greuze and Gericault.

The furniture collected by the royal house throughout the second half of the 19th century mirrored its European counterparts. Continuously enriched during a prosperous period when copying was at its peak, the collection exemplifies the eclecticism of the time: multiple European styles mixed with oriental, exotic and naturalistic influences.

The taste for contrasts, combined with the demand for comfort and functionality in furniture, is evident in the work of Portuguese and foreign craftsmen, including Leandro Braga, Sormani, Lelarge, I. Lebas, C. Chevigny, Giroux,

Quignon, Boudet, M. Krieger and Escalier de Cristal.

There are also remarkable sets of porcelain from Sévres, Limoges, Saxe and China, together with utilitarian, decorative and lighting glass, which include pieces from the main glass manufacturing and trading centres in Europe at that time, such as Bohemia (Moser), Italy (Companhia de Venezia/ Murano, Salviati, Fratelli Toso and M. Q. Testolini), France (Baccarat, Daum, Gallé, School of Nancy), Spain (La Granja and the Catalonia region), Austria (J&L Lobmeyr), England (Thomas Webb & Sons), Germany and Portugal.

The textiles are also characterised by a great diversity of types, techniques, places and dates of origin. Dating back to the 17th and 18th centuries, this diverse set of objects was part of the daily life of the Royal Family during the twilight of the Portuguese Monarchy. The collections of 18th century European tapestries, Aubusson, Gobelins, La Granja, oriental cloths and carpets, door cloths and vestments from the Royal Chapel, clothing and ornamental pieces from the 18th century and earlier are all fine examples of this.

The Ajuda Library is one of the oldest in Portugal and is characterised by the nature and richness of its collections. Its origins date back to the 15th century under its former name, the Royal Library. Today, it is a historical archive open to researchers. Following the Peninsular War, the library was transferred to Rio de Janeiro, to join the Court, where it formed the initial nucleus of the current National Library. In 1821, the Royal House's manuscript centre returned to Portugal, later joined by the Society of Jesus libraries: the Professed House of St Roch and Santo Antão College, as well as those of the Congregation of the Oratory and Necessidades Palace. Housing a major collection of Portuguese heritage, the Library's 3 km of shelves hold a total of around 150,000 items, manuscripts and printed matter, including

some unique and well-known works, such as the *Cancioneiro da Ajuda*, the *Livro de Traças de Carpintaria*, and *Da fábrica que falece à cidade de Lisboa* by Francisco d'Holanda.

The Manuscript Collection has 2,512 codices and around 33,000 loose documents (13th to 20th century), including 43 illuminated codices, scripts and atlases, bibles, historical and literary miscellanies, as well as an important collection of chronicles (15th to 18th century), nobiliaries and genealogies. The 226 codices of the *Symmicta Lusitanica* and 61 codices of the *Jesuits in Asia* are fundamental to the history of the Orient (18th century).

The Royal Treasure Museum, inaugurated in 2022 and designed by João Carlos Santos, made it possible, after almost 200 years, to complete the palace.

Due to various vicissitudes, none of the many other projects put forward over the years ever saw the light of day.

2016 saw the project that is now the Royal Treasure Museum able to move forward through an agreement to finance the completion of the Palace signed by the Ministry of Culture, the Directorate General for Cultural Heritage, the Lisbon Tourism Association and Lisbon City Council. The contents for the museum programme had been adjusted by the Palace team the previous year, in collaboration with the project's author. Given its scope – more than 1,000 pieces – it was rightly named the Royal Treasure. Building work began in 2018.

The collection is internationally unique in terms of its size, rarity and quality. There is a large clod of gold, various nuggets, coins and medals also in gold, from national jewellers such as Estêvão de Souza, Casa Leitão & Irmão and internationally renowned jewellers like Fabergé and Castellani. Amongst the other items, the diadem and necklace with stars set with diamonds are outstanding: a very impressive group commissioned by Maria Pia. Also on display is the gold crown (pp.

102/103) made in Rio de Janeiro for the Proclamation of João VI, sceptres (pp. 101, 112), cloaks (p. 6), rapiers and insignia that still represent the country today. There is also the piece considered the most important jewel in the royal collections at the end of the 18th century: the Large Badge of the Three Military Orders (p. 87), which makes a set with the plaque (p. 85) and miniature (p. 86) of the same orders. Next, in terms of artistic, historical and gemmological interest is the large emerald bodice ornament (p. 77) of the Queen of Spain, Bárbara of Portugal, born a Portuguese *infanta*, This is not to forget King José's tobacco box (pp. 59, 60) , commissioned from one of Luís XV's jewellers, internationally considered a masterpiece of its kind. Furthermore, of course, the insignia of the *o* (Order of the Golden Fleece) (p. 96) of King João VI is the largest of its kind in existence.

Alongside the jewellery, there is a collection of 16th century Portuguese civil use silverware, the largest in the world, comprising salvers, plates and water jugs that are crafted with great virtuosity in terms of both technique and decoration, reflecting a golden past (p. 10).

They are in the section dedicated to the Crown's ceremonial silver, as well as in the private collections of Ferdinand II and his son, Luís I, where Portuguese pieces dialogue with notable works from other production centres. At the end of the exhibition route, visitors will find the *Baixela da Coroa* (Crown Service), designed by François-Thomas Germain (1726-1791) and which is the largest preserved collection of 18th century French jewellery. The Ajuda National Palace - Royal Treasure Museum is a fitting setting for the presentation of a unique collection that is particularly significant for a country with a history spanning nine centuries. The jewellery, decorations, coins, religious and civil jewellery express the wealth of a people and bear witness to the heights achieved by the decorative arts.

The Royal Treasures, national symbols, are now on permanent display in the same palace where the monarchy's last private quarters and ceremonial rooms were located.

Sparkling Sovereigns
The Story of a Dynasty

The House of Braganza

by Giuseppe Scaraffia

Luisa de Guzmán
(1613–1666)

"I would prefer to be queen for a day than a duchess for life" was Luisa de Guzmán's legendary response to the objections of her husband, João (1604–1656), who was uncertain whether to take the plunge and join the conspiracy that would bring him to the throne. Luisa did not find it easy to stir her husband into action. João, the eighth Duke of Braganza, was very wealthy and just wanted a quiet life. However, circumstances were favourable for liberating Portugal from the rule of the Spanish Habsburgs. The introduction of new taxes had exasperated the people, and the nobility and bourgeoisie had launched an anti-Spanish revolt. However, they needed a credible leader, and João, descended from King Manuel I (1469–1521), was the most suitable candidate. His beautiful wife, the daughter of the powerful Duke of Medina Sidonia, pressed him repeatedly until he accepted the throne offered to him. The duke agreed to head the revolt and when this ended in victory, he was proclaimed King of Portugal on 1 December 1640 with the name of João IV. A clear echo of Luisa's important role in this decision can be found in *Braganza* (1775), an English play by Robert Jephson about the Portuguese revolution of 1640. The protagonist tells her reluctant spouse: *I have a woman's form, a woman's fears, / I shrink from pain… / To shun them is great Nature's prime command; / Yet summon'd as we are, your honour pledg'd, / Your own just rights engag'd, your country's fate, / Let threat'ning death assume his direct form, / Let dangers multiply, still would I on, / Still urge, exhort, confirm thy constancy; / And though we perish'd in the bold attempt, / With my last breath I'd bless the glorious cause, / And think it happiness to die so nobly.* To which the duke replies: *O thou hast roused me—From this hour I banish / Each fond solicitude that hover'd round thee: / Thy voice,—thy looks—thy soul are heav'n's own fire. / 'Twere impious but to doubt that pow'r ordain'd thee / To guide me to this glorious enterprise.*

The testimony of Richard Flecknoe, an English priest and author who was in Lisbon in 1648, confirms the balance of the couple: *The King is an honest plain man … faring as homely as any* Farmer, *and going as meanly clad as any* Citizen *… his ordinary Exercise is* Hunting, *and* Musick *… But for the Queen, she has more of the Majestick in her, and if she be not King, her Ambition 'twas that made the King.* Not only did she have "a goodly presence, a stately Gate"; but when her husband, before dying, appointed her regent until their son came of age, she demonstrated great resoluteness and ability from 1656 to 1661. She promoted the important alliance with England, reinforced by the marriage of her daughter, Catherine (1638–1705) to Carlos II (1630–1685).

Of their seven children, the eldest, Prince Teodósio (1634–1653), tall and slender, refined, intelligent and brave, seemed to have all the requisite qualities of a ruler, but he died when he was nineteen. His brother Afonso VI (1643–1683), after ascending the throne, proved a disappointment for everyone but especially for his mother. Handsome, blonde and

It was Cornelia, the mother of the Gracchi, important figures in the republican age of ancient Rome, who, by exclaiming "Haec ornamenta mea" ("Here are my jewels") in relation to her sons, first established, perhaps unconsciously, a link between jewels and the family. The connection has survived to this day, and in some languages has even produced colourful and ironic colloquial expressions.

It is an incontrovertible fact that jewels, and precious objects in general, accompanied the ruling European dynasties over the centuries, and were handed down, migrated and scattered like the surnames on the genealogical trees of the great royal families. Like silent, unmoving witnesses, sticking out of dizzying headdresses, clasping pale arms, skilfully inserted into the folds of clothing, dangling from ears or elegantly encircling necks, jewels looked upon unfolding events from a privileged position, from the royal stage, the balcony of honour.

On the other hand, the queens and princesses who wore them did not just observe history. Indeed, they played a much more active part in history than their husbands and fathers might have liked to admit, unlike jewels, which only rarely were anything other than silent, glittering observers. This is precisely why the history of the house of Braganza will be presented in these pages through the vicissitudes of the queens who were born or married into the family: faceted and brilliant like their jewels, they will be excellent travel companions, revealing unexpected aspects and curious details of the history of Portugal.

blue-eyed, he suffered from epilepsy and had an unpredictable character. The people and the aristocracy looked on with concern at the actions of a sovereign "weak in body and mind, lacking in virtues and blindly attached to insolent and villainous men". He chose his friends from among the most wicked in the city, and they lounged around in the palace insulting nobles and servants alike. During processions, followed with great devotion in Portugal, they amused themselves by charging wildly into the crowds on their rearing horses and causing a considerable number of deaths. When an attempt was made to separate the king from the worst of the bunch by forcibly embarking them on a ship for Brazil, Afonso exploded with rage. The queen, believed by her son to have come up with the idea of the kidnapping, had to retreat to a convent, where she died four years later in 1666, at the age of fifty-two. Lady Fanshawe, the wife of the English ambassador, noted in her memoirs: *Truly she was a very honourable, wise woman, and I believe had been very handsome. She was magnificent in her discourse and nature, but in the prudentist manner; she was ambitious, but not vain; she loved government, and I do believe the quitting of it did shorten her life.*

Catherine of Braganza (1638–1705)

Catherine's marriage was arranged by her mother, the ambitious Luisa de Guzmán, who became regent after the death of her husband. Catherine had reputedly not ventured into the outside world more than about a dozen times in her whole life. With a pale face framed by dark curls and a slender nose above a sensual mouth, Catherine was unquestionably pretty for a princess. Unfortunately, the proud confidence in her beautiful eyes was destined to fade away in contact with the frivolity of the English court, distinguished by a never-ending amorous merry-go-round centring on the pleasure-seeking sovereign, Carlos II, nicknamed the Merry Monarch. The union of Catherine and Carlos, however, was based on something much more solid: the need for Portugal and England to offset the Peace of the Pyrenees, the worrying alliance between France and Spain.

Catherine had an opulent dowry, which ranged from Tangiers to Bombay, and the Braganza ship that brought her to England also carried something that would profoundly influence British life and almost come to represent it: tea. The name was said to derive from the wording on the packing crates: "Transporte de Ervas Aromaticas" or Transport of Aromatic Herbs. The new drink was served in the handle-less cups of the queen's blue and white porcelain services. Sugar, used as ballast on her ship, soon replaced honey and the king confirmed the choice of tea by obstructing the spreading consumption of coffee, regarded as a subversive beverage. Though it had arrived in Great Britain some years earlier, tea triumphed thanks to its adoption at court.

According to some, the fickle-hearted Carlos II's infatuation for his young bride lasted around a month, while for others it never existed in the first place. Catherine, on the other hand, apparently loved him to the end. Other voices recount that the groom kept her waiting for a week, in May

1662, because his favourite lover, Lady Castlemaine (1640–1709), the "queen without a crown", was giving birth to his child. Sensual and uninhibited, she enjoyed Carlos's affections, though she did not forego her own fancies or make him forego his. She was a troublesome presence for the young bride, who also could not tolerate her habit of helping herself freely to the royal treasure. Yet after her husband's lover gave birth to the king's second illegitimate child, Catherine had to resign herself, after many furious rows, to meeting her in public, whereupon she promptly fainted. This profoundly vexed the sovereign, who for a while kept her away from court life, despite her threats to return to Portugal. The rift flared up again when the queen refused to choose his lover from among the candidates for the role of Lady of the Bedchamber. At that point, Carlos did not just install Lady Castlemaine in an apartment above his own but also admitted her to the royal table, publicly ignoring the queen. When Catherine, almost alone following the return of most of her retinue to Portugal, finally relented, the king demonstrated immense gratitude to her and his lover became one of Catherine's great supporters.

At court, there was ironic talk about her six ladies in waiting, nicknamed "the monsters", and about her Catholic chaplain, who was viewed with suspicion by her Protestant subjects. Five other chaplains had also come with her from Lisbon, plus four bakers and a Jewish perfumier. Nonetheless, the greatest source of curiosity was a figure apparently without responsibilities, maliciously nicknamed "the Infanta's barber". It was rumoured that the fleet sent to fetch Catherine remained in Lisbon for six weeks, enough time for the future queen to regrow the down of which the royal groom was very fond. Spiteful voices whispered that the Portuguese were accustomed to depilating themselves completely, like Orientals. It was a ridiculous insinuation, given the modesty and religiosity of the House of Braganza, but it offers a useful measure of her unpopularity in a totally foreign environment. Not everyone detested her, however. One less prejudiced courtier, Anthony Hamilton, though not finding her particularly beautiful, acknowledged her remarkable intelligence and a rare ability to discern people's qualities. The diarist Samuel Pepys, who had occasion to visit the queen's rooms thanks to a friend, was amazed by the sober furnishings, very different from the profusion of pictures and precious objects in the king's apartment. There were just religious paintings and, close to her bed, a clock illuminated day and night by a candle.

The departure of most of her retinue prompted Catherine to emerge from her isolation, improve her English and even learn to dance. She settled in so well that in 1670, when the court was in the countryside, she went on a caper with two duchesses: dressed as peasants they turned up at a local fair but were recognized immediately and had to beat a hasty retreat. On another occasion, again in disguise, she went all the way to Newport to buy hose for a purported lover, in all likelihood her husband. This is without mentioning the forays of the whole court, which used to turn up, masked, at the house of strangers; on one of these expeditions those responsible for taking the queen back home did not recognize her and left her there.

Despite their differences in character, the king did not hesitate to defend her when, in 1678, following a false Catholic plot, she was publicly accused of seeking to poison her husband. The Italian philosopher, author and diplomat, Lorenzo Magalotti reported that Catherine, who was extremely religious, devoted a lot of time to Masses, rosaries and Vespers, but also spent three or four hours a day in her room playing cards with either ladies or gentlemen. Her "very high opinion of herself, her dynasty and her country", together with her stubbornness, made her inflexible. "Highly sensitive to pleasures", she amazed courtiers by limiting herself to those rarely offered by the monarch.

Pages 48/49
English school
Double portrait of Carlos II and Catherine of Braganza. *ca. 1665*
Oil on canvas

She did not drink wine, just a great deal of water at the end of meals. She was not, as rumour had it, indifferent to the arts and music, which she actually encouraged in various ways. Her hostility to the influence of French culture led her to favour Italian composers, whose works she promoted in England. Still in love with her husband, Catherine tried without any great success to please him by organizing parties and amusements. Luckily for her, her failure to produce issue – she suffered the humiliation of three miscarriages – did not concern the king, who had happily accumulated numerous illegitimate children. When she had a close brush with death due to a violent fever, the king was touched by her courage and, though he did not love her, esteemed her greatly. While, in tears, she expressed the wish that he would find a better suited wife, she realized that Carlos was also upset and crying. Feeling that he was beseeching her to live for his sake, she made an unexpected recovery, though she was forced to resign herself to the insuperable indifference of her husband, who was always absorbed by new loves. Widowed in 1685 following the sudden death of Carlos, who converted to Catholicism on his deathbed, Catherine became embroiled in a legal case to regain part of her allowance, which gave her enemies the opportunity to point out her tenacious attachment to money. Luís XIV (1638–1715) made her wait for a long time before granting her permission to cross France on her way to Portugal because she was suspected of being married to the man accompanying her, the Protestant Luís de Duras, Count of Feversham (1641–1709). On the gable of the Bemposta Palace, her new residence in Lisbon, the Stuart coat of arms flanked that of the Braganza. The quiet pace of her new life as a widow was interrupted by the deepening depression of the King of Portugal, and she was obliged to become regent in 1704, foregoing her gentle tea rituals with the English nuns. However, she died following a sudden illness shortly afterwards.

Maria Francisca of Savoy (1646–1683)

Did Maria Francisca of Savoy know about what her betrothed got up to? Did she know that Afonso VI spent his time with a bunch of scoundrels? And that once, in a very religious country like Portugal, he broke into a convent with his wild friends and forced the nuns, woken in the middle of the night, to join in their revels? And that anyone who criticized the king and his friends might disappear from one moment to the next?

She probably did, because while in public she put on a show of being proud to ascend the throne, in private she confessed: "I'm going to Portugal to earn my place in heaven." The *Grande Mademoiselle* – the daughter of Gaston, Duke of Orléans (1608–1660), who was the brother of King Luís XIII (1601–1643) – had been the first candidate for the throne, but astutely allowed the insidious proposal to drop. Mademoiselle d'Aumale, the daughter of a Savoy and a Vendôme, seemed perfect for that problematic union, as she was the cousin of Luís XIV.

Unfortunately, the plan to have Maria escorted by the widow of Paul Scarron, the able and intelligent Madame de Maintenon, had come to nothing and it was her uncle, the Duke of Beaufort (1616–1669), who had killed her father in a duel, who accompanied her to her new country with a whole naval squadron. The groom's eccentrically sumptuous attire, the excess of precious lace, two hats worn on top of each other, seemed provincial to a young lady fresh from the most elegant court of the age. Not to mention his shifty air, unhealthy pallor and a precocious double chin, the result of the young monarch's continual binges. Their first night together bore out that first impression: after draining a bottle of wine and boasting that he had dispatched his mother to a convent, Afonso VI fell asleep. Nor was the marriage consummated in the days that followed; the king being too accustomed to prostitutes to take an interest in his wife.

Isabel Luísa
(1669–1690)

The Infanta Isabel Luísa of Braganza was the only child Pedro II of Portugal had with Maria Francisca of Savoy. Intelligent and lively, she had a sweet, gentle character. In the first years of her life, she demonstrated a pride that impressed her energetic mother. She also loved studying: she spoke Spanish, Italian and French, and had a passion for history and geography (especially that of Portugal), a fondness for poetry and a gift for music. Her aptitude for learning was heightened by the queen's constant presence at her lessons, who skilfully guided her curiosity and reasoning. Convinced that a child's early-year experiences were crucial, Maria of Savoy never let her out of her sight and had her daughter sleep in her room. At her court debut, Isabel Luísa surprised everyone with her intelligence, good sense and religious piety. It seemed as if she was fearful of displeasing the queen and was able to anticipate her every desire. Maria produced a kind of catechism of teaching for her, which Isabel followed scrupulously. Aware of the duplicity of courtiers, the queen warned her: "Remember, my daughter, that those who adulate your defects and speak only to please you, do so exclusively for their own ends. On the other hand, always esteem your most zealous and faithful servants, those who tell the truth even at the cost of angering you."
The Infanta's reputation for virtue was very widespread. Madame d'Aulnoy, the French writer known for her fairy tales, had heard talk of her at court in Madrid, despite the ongoing rivalry between Spain and Portugal. In a portrait she had seen, Isabel Luísa seemed delightful, her hair cut and curled "like an abbot's wig" and a farthingale so large it could have borne two baskets of flowers.
It was thought that she would ascend the throne and, at the age of five, she had sworn an oath before the national assembly. However, the birth of her half-brother João in 1689 from her father's second wife put paid to that. Nothing, however, diminished the deep affection binding the new queen, Maria Sophia of Neuburg, and Isabel Luísa, who was just three years younger. The pair were inseparable, always to be seen together in the palace.
At this point, the matchmaking machine went to work. After the plan to have her marry Luís XIV's son, the Grand Dauphin Luís (1661–1711), fell through, the king fell back on the highly ambitious Prince Victor Amadeus of Savoy (1666–1732). Victor was Isabel's first cousin on the side of his aunt, Marie Jeanne (1644–1724) and was still in search of a crown. The proposal was strongly opposed in the family because the departure of the prince for Portugal would have left power in the hands of his mother, who he hated. However, an incident scuppered the problematic plan: the Sun King had put his fleet at Victor Amadeus's disposition in order to travel to Lisbon, but the Portuguese, who could not accept the idea of the future king arriving on a foreign ship, dispatched the Duke of Cadaval to Nice with his ships to bring him to Portugal. However, as the Duke of Saint-Simon reported, the future groom turned down the offer of transportation and refused to go through with the marriage. Various other illustrious candidates were mooted for the hand of Isabel, known as the Princess of Beira, ranging from Ferdinando de' Medici (1663–1713) and his brother Gian Gastone (1671–1737) to the melancholic Carlos II of Spain (1661–1700); the Duke of Parma and the Count of Neuburg. Nothing came of the proposals, however, which was why the poor princess became known as the "always engaged". Inconsolable at the loss of her step-mother, Isabel Luísa caught smallpox, which was particularly virulent in Portugal. Before succumbing, she suffered a great deal from the pointless treatments she received, but never complained.

Page 54
Josefa de Óbidos (1630-1684)
Isabel Luisa, *ca. 1680*
Oil on canvas
National Coach Museum, Lisbon

Maria Anna of Austria (1683–1754)

Proud and religious, Maria Anna of Austria rarely went out except for Sundays to attend Mass at the Church of Saint Roch. Her face carefully protected by a veil of black tulle, all she had on her hand was a ring with an eagle, the crest of the Holy Roman Empire. She confessed and took communion each time, imitated by her children, relatives and ladies in waiting, and then by the rest of the respectful congregation. The daughter of Emperor Leopold I and Eleonore of Neuburg, she attended many churches and convents, but would only kneel before the elderly blind abbess of the convent run by German nuns. Her majestic northern European beauty can clearly be seen in equestrian portraits. Like every good Habsburg, she had inherited a passion for horse riding. In Pompeo Batoni's painting, the young queen has an alert and haughty air. Her blonde hair beneath the powder highlights her pale complexion.

Most of the streets in Lisbon were so narrow that carriages struggled to get through, forcing many notables to move around in litters. Only the roads enlarged by João V, the "Portuguese Sun King", were wide enough to permit the passage of the magnificent royal carriages. The low, long ones of the courtiers, emblazoned with gleaming coats of arms, warriors and animals, looked as if they had passed beneath a shower of gold. The king's carriage speed through the streets, while the queen's had a more moderate pace, followed by those of her ladies in waiting. The king dressed sumptuously, with the courtiers trying to imitate him. The royals had more than a hundred servants, many being black, who were only remunerated with modest board and lodgings. In the palaces, however, the glittering silverware formed fanciful centrepieces rising into the air towards frescoed ceilings.

During processions the people genuflected when the queen, who, beneath her magnificently embroidered clothes, was as fat as her husband, passed by. Their marriage was celebrated "with every possible and imaginable magnificence" and confirmed the alliance between Portugal and Austria against the Spanish and French Bourbons in the War of the Spanish Succession. Tall and majestic, João V, known also as "the king of gold" and "the modern Solomon", looked upon his subjects with satisfaction with dark eyes that stood out against his pale complexion. The queen spent most of her time in her rooms, chatting with her lady companions or playing with her dogs. The Lisbon earthquake would destroy the ceilings frescoed by the young court painter, Pierre-Antoine Quillard. A painter, draughtsman and engraver, he had been invited to Lisbon by Carlos-Frédéric Merveilleux, the king's Swiss doctor. Merveilleux, who wrote some illuminating memoirs about Portugal, had summoned Quillard to illustrate a herbal on the region's plant varieties. However, the hereditary prince, José, was so taken by the sensual melancholy imbuing all the output of Watteau's pupil that Quillard's elegant fantasies adorned the king's carriages and the queen's furnishings.

João V, also known as "the Magnanimous", was attracted to women. It was said that, during audiences, his gaze was prone to linger on the delights revealed by the ladies when they knelt before the throne. This was the man who had personally ordered the building of the palace and convent of Mafra, and often visited the convent of Odivelos.

The presence of his entourage, a confessor, a physician, a gentleman-in-waiting and a valet did not stop him from admiring the most noble and attractive of the young nuns, selected by the abbess. One in particular took his fancy, a young girl who was in love with another man and had rejected the king's advances and the riches he dangled before her. In fact, she retreated to a convent to escape the king's insistent courtship. The woman she chose as her companion, Paula de Odivelas (1701–1768), ably passed from being her

confidante to being the king's lover. He showered her with gifts, and she bore him a son, later to become Inquisitor-General. When the king decided to end their relationship, Paula sent back to the court all the magnificent furnishings with which she had been rewarded by her lover. The queen was aware of her husband's frequent dalliances, which required him to use stimulants, but had never intervened. Only Luísa Clara, who had seduced the king so completely that she managed to get him to appoint a shoemaker brother of hers as a diplomat to the papal court, had irritated her so much that she tried, in vain, to banish her from receptions at court. In any case, the king's amorous tendencies did not stop him fathering a child with one of the attractive chamber maids. In the final active years of his life, João V, perhaps alarmed by the threats of hell raised by the nuns and his confessor, devoted himself principally to charitable works.

When a stroke in 1742 left João partially paralyzed and his mind impaired, Maria Anna, who had begun to dye her hair blue, assumed the regency. She served in this role until the king's death eight years later, which enabled their elder son, José (1714–1777), to ascend the throne. In this period, the queen re-established the traditional customs of the court, increasing the already marked separation between the sexes, and similarly between servants and lords. However, her grand social events, often associated with religious occasions, were legendary for their magnificence and the large numbers of eminent guests. When she died, she was buried in the church of the German Discalced Carmelites in Lisbon, but her heart, taken to Vienna by her confessor, was placed in a Rococo urn made by the sculptor Balthasar Ferdinand Moll in the Leopold Chapel of the Imperial Crypt.

Maria Bárbara
(1711–1758)

João V's entry into his wife's bedroom had involved a complex ritual; clusters of servants and aristocrats hovered around him, relieving him of his daytime attire, dressing him with his night garments and preparing him for an encounter with his wife, Maria Anna of Habsburg. Queen Maria Anna whiled away the time chatting about religious matters with her lady in waiting until the king appeared with a lighted candle in his hand. Following reverent greetings, and after their attendants had withdrawn, leaving them in long nightgowns, the king and queen diligently tried to conceive the future sovereign of Portugal.

The heavy Austrian eiderdown which the queen insisted on using even in the summer made the whole operation more awkward. It was rumoured that the tester bed, covered with precious hangings which the king had ordered from Holland, was inhabited by bedbugs, very much at home in the palace beds. When they had finished, the queen summoned her ladies and her husband's attendants by pulling a bell cord. Then, when her husband had left, she went to sleep reciting the rosary.

The absence of children made the queen's situation problematic, especially as the king had shown on various occasions that he was able to generate them without difficulty. It was then that the Inquisitor-General, the Franciscan cardinal Nuno da Cunha e Ataíde, assured the monarch that his wife would conceive if he had a huge convent built at Mafra. This came to pass and, after giving birth to a baby girl, Maria Bárbara, the queen had several more children, all of whom were male.

Maria Bárbara's parents became concerned when they found out that their daughter sang and danced when she was on her own. When asked the reason for this strange behaviour, she replied with unassuming firmness that it made her feel less lonely. Encouraged by this unexpected curiosity about her life, she went on to explain that

she liked the psalms sung in church and the music her mother played. When a famous composer, the Italian Domenico Scarlatti, arrived in Lisbon in 1719, the king, who, like his wife, was a great music lover, asked him to gauge the musical aptitude of his brother and son. Scarlatti was also asked whether he could use the full authority of his fame to persuade young Maria Bárbara to abandon music and singing, for which, in her father's view, she had not the slightest aptitude. But Scarlatti, after having diplomatically expressed his opinion about the musical talents of the two Braganzas, spoke to the king of the young girl's exceptional ear for music. This led to a great friendship between the thirty-year-old musician, a meek, taciturn man always dressed modestly in black with an old wig on his head, and the princess condemned to solitude.

The unusual bond did not escape the constant surveillance of the priests that thronged the palace and followed every change with suspicion. Scarlatti was also questioned by the inquisitors, but, thanks to his discretion and reserve, he eluded their traps. Even the curious relationship between Maria Bárbara and a colourful parrot imprisoned in an aviary was assiduously observed and reported on, as were the words with which the girl addressed the bird every day from a window. In fact, she was not allowed into the garden, out of fear that she might fall ill and die like the second-born child. Nevertheless, through gentle determination, in the end she obtained permission to approach the cage where, before the perplexed gaze of courtiers, she spoke at length to the parrot. Her governess had to intervene to enable the princess to continue talking to the bird without witnesses. When asked why she called the parrot Renato de Souza, she left everyone speechless by explaining that the bird had introduced itself by that name.

Maria Bárbara was not particularly attractive. She was not tall, had wide hips and a tendency to put on weight. She did,

however, have a hidden gracefulness that appeared in her gestures; and her strange way of walking was almost a slow dance across the carpets of the reception rooms. She listened with affectionate indifference to the insults of her younger brother José, the heir to the throne, who called her "sow" because of her pig-like eyes, or "Port flask" or "Madam know-it-all" due to her love of reading. Ever obedient, the girl smiled respectfully, but did not hesitate to decline the invitations of her father, who loved hunting, to take part in deer and boar hunts.

When the Spanish royals sent a portraitist to Lisbon prior to Maria Bárbara's marriage to the heir to the Spanish throne, Ferdinand of Bourbon (1713–1759), João V, worried that his daughter was not very attractive, did everything he could to keep the artist away from her, citing mysterious allergies. The marriage was celebrated in a magnificent building erected on a bridge at the fragile border between Portugal and Spain, the same place where another princess, Mariana Vitoria of Bourbon (1718–1781), met José (1714–1777), the future King of Portugal and Bárbara's younger brother.

Despite some pockmarks from smallpox – common at the time, and indeed Ferdinand had also had it – which Maria Bárbara, unlike many others, did not try to hide with make-up, the heir to the Spanish throne was unexpectedly taken with her. The French ambassador, who esteemed her, judged Maria Bárbara to be a royal highness "of excellent character, always well disposed, extremely polite and well-mannered, attentive and considerate". With a shared love of music, the union between Maria Bárbara and Ferdinand was one of the rare happy marriages between crowned heads. Not even her tendency to put on weight and her failure in one of the chief missions of a queen, to procreate (the only child conceived was stillborn) diminished her husband's affection. Worn down by asthma, Maria Bárbara died in 1758 at the age of forty-six, a year after Scarlatti. She left the 555 harpsichord

sonatas composed for her by the musician to a great castrato, Farinelli, whose singing seemed the only thing able to calm the anguish of Philip V of Spain (1683–1746). Devastated by grief, Ferdinand did not even attend her funeral. He retired to a castle in the hope of distracting himself by hunting, but to no avail. He fell into depression, tried to commit suicide several times and then stopped washing and eating, shutting himself up in a small room, where he died a year after the queen.

Mariana Vitoria of Spain (1718–1781)

It was very cold on 8 January 1722 on Pheasant Island, situated on the River Bidasoa on the border between Spain and France. Two princesses found themselves there for an exchange. Luíse Élisabeth de Montpensier, daughter of Philippe of Orléans, Regent of France, was thirteen; and the Infanta Mariana Vitoria of Spain, the first daughter of the King of Spain, Philip V, was three. Despite their young age, royal weddings had been arranged for both: the former would become the Queen of Spain, by marrying the Crown Prince and future King Luís of Spain (1707–1724); while the latter was to have become the Queen of France by marrying the adolescent Luís XV (1710–1774). Any girl might have felt lost when most of her entourage departed, leaving her with strangers who spoke another language. Not Mariana Vitoria, however, who soon learnt French and assembled a small court of dolls and ducklings. Her betrothed, who had given her a doll as a welcome gift, treated her with respect but kept his distance, unlike the rest of the court. They were delighted by the grace of the "Queen-Infanta", as she was called, who was always cheerful and well-mannered. According to the regent's mother, Elizabeth Charlotte of the Palatinate (1652–1722), Mariana Vitoria, the "sweetest and prettiest little thing", had remarkable spirit for her age. A court intrigue orchestrated by the Duke of Bourbon ended with her being cruelly sent back to Spain, without any warning to her parents, with the excuse that, due to his delicate health, Luís XV could not afford to wait too many years to procreate. This great offence was destined to upset the already precarious political balance in Europe. In 1729, at the age of nine, Mariana Vitoria married José (1714–1777), Prince of Brazil, who would ascend the throne in 1750. The marriage between the Infanta of Portugal, Maria Bárbara, and the future King of Spain, however, had sealed the alliance between those two nations.

Page 65
Nicolas de Largillièrre (1656-1746)
Mariana Vitoria of Spain, *1724*
Oil on canvas
The Prado Museum, Madrid

Mariana wrote to her mother in Spa every week, telling her about her Latin and grammar lessons, the characteristics of the royal family and how many rabbits she killed in hunts. In March 1745, while mourning the death of her grandmother, she complained: "The king thinks of nothing but the Patriarchate and the queen does nothing: we live the most unpleasant life in the world. If I did not have the freedom to go out sometimes, I don't know how I could live."

Going out involved visits to churches and convents, of little interest to a young princess. "As I like riding a lot, I enjoy myself in this way and with singing when I return or if I do not go out. For a few months now, I have also had another amusement, going to play [cards?] in the evenings in the apartment of some nobles who are part of the family." Though she added: "My prince [José] is not so attached to these customs but does everything possible to give me pleasure."

At times, however, she could not avoid recording the absurdities of the old-fashioned court: "Dear mother, I'll tell you this story so you can see the stupid things that are said here. For an injury to his hand that had been hurting him for a long time, my prince was advised to have a bull brought to him and killed, and to put his hand inside to strengthen it. At the same time, it was said that the meat of the bull brought for him could not be eaten, poisoned as it was by the bad humours that would remain inside. Could there be anything more senseless?" Despite her restraint, the young bride had to admit that listening to nonsense like this made her angry.

The king was tall but inclined to corpulence. No peasant, a traveller noted, had bigger or darker hands than his. One could not look at his "face, as bronzed as that of a Moor, without remembering how close the coasts are and how similar the climes of Portugal and Africa." His lively gaze might also have been noted "if the habit of keeping his mouth open a little had not diminished the intelligent expression that his face would otherwise have conveyed."

In 1734, two years after the consummation of the marriage, the first of the couple's eight children was born. Was the queen religious? The Italian, Giuseppe Baretti, wrote that it was "her habit to kiss the names of God, of our Blessed Lady and of all the saints and angels in every book she opened". But those who, like another Italian, Giuseppe Gorani, saw her in church, noted that she did not seem particularly absorbed by the service. Unlike many of his predecessors, José I was not over-devout either, as he demonstrated by his expulsion of the Jesuits, who had long been masters of the Portuguese political scene. The queen's hostility towards the Marquis of Pombal (1699–1782) did not influence the king's relationship with his minister, who also had the support of the queen mother. However, Mariana Vitoria's close ties with Spain had avoided a full-blown war between the two countries.

Though he was not interested in art or literature, the king protected people of culture. Court life had not changed and there was still the antiquated, uncomfortable rule that courtiers could not sit in the presence of sovereigns. Even the secretary of state and the ministers had to kneel. Despite the important reforms introduced by the Marquis of Pombal, who ruled the nation in agreement with the king, the ever more impoverished population remained unhappy.

José I's great passions were music and hunting, which were shared by his wife. The hunting expeditions, which ranged from Mafra to Vila Viçosa and Salvaterra, were exhausting for the courtiers, who had to get up at dawn to accompany the monarchs whatever the weather, moving around in uncomfortable, draughty carriages. The Spanish ambassador nicknamed the king "His Majesty the Pleurisy". The mere mention of yet another hunting expedition was enough to trigger a nervous breakdown in one lady, while others cited various health issues in an

effort to get out of going. As if deer and wild boar were not enough, sometimes the royal family sailed from Salvaterra to hunt the whales that occasionally swam up the river.

Unlike her father-in-law João V, the king shunned luxury and went around in an old, rickety carriage. The servants at court suffered the consequences of this general neglect. They were not paid for many years and eked out an existence with difficulty. Besides hunting, the biggest investment made by the royals was in music. The king played the violin well, Mariana Vitoria was a fine singer and their three daughters also played various instruments.

José I went to the opera and to bullfights every week, often incognito as two attempts had been made on his life. Out of caution, he would move during the show from the royal box into one of the secondary ones. Women were not allowed to perform at the theatre or opera, a prohibition attributed to the jealousy of the queen but which remained in place after her death. Despite the magnificent stagings, the absence of a female presence on stage resulted in a rather gloomy atmosphere. The noblemen, who occupied the stalls area, had to bow twice before taking their seats: once to the royal family and then to the ladies, seated in the boxes.

The queen was always at her husband's side. Flouting the common rules of decency, which demanded that women should ride side-saddle, with both legs on one side of the horse, Mariana Vitoria boldly sat astride her horse. For reasons of comfort, she wore black leather trousers brought over from England, with a petticoat on top. Expert at hunting with a falcon, she was also an excellent shot. Everyone was therefore amazed when a bullet from her weapon grazed her husband's temple, an incident that many put down to a dalliance the king had had with a young marquess. One day, hearing the father of the young woman praising her husband's horsemanship, she replied: "He's better astride your daughter!" It was while he was on his way back from a secret encounter with the marquess that the king had been the victim of an attempted assassination. Wracked by jealousy, Mariana Vitoria watched her husband's every movement and glance with the anxiety of a young bride. To avoid putting temptation in his way, she surrounded herself with elderly and generally unattractive ladies in waiting. Notwithstanding these precautions, the king had, in great secrecy, taken numerous lovers, much to the annoyance of his strong-willed wife.

At the time of the earthquake that devastated Lisbon in 1755, the king and his court were away. After the disaster, however, José I began to suffer from claustrophobia, and he was unable to sleep indoors. His sumptuous palaces remained empty, and large tents or ramshackle wooden constructions were used instead. In fact, the earthquake had spared those living in wooden homes.

The catastrophe also led to another change: before the earthquake, the king had not been a wine drinker, but when his physicians recommended it to alleviate his depression, he began to drink to excess. The assassination attempt he had suffered as part of a conspiracy of aristocrats worsened his melancholy, and a series of strokes prompted him to hand over the throne to his wife in 1776. Observers in that period described her as small and fat, no longer with "anything feminine" about her. Very robust, and always with a low neckline, even in church, at the opera or at bullfights, she had deeply sunburnt arms, the result of her many hunting sessions. But her dark eyes, in a reddened face dominated by a large nose, remained lively and penetrating.

During a trip to Spain in 1778, an attack of rheumatism left her confined to a wheelchair. She died three years later. In her final years, as she was unable to ride, she hunted from a sedan chair and shot a large number of deer and rabbits.

Page 73
François-Thomas Germain
Tureen and stand, with the cover finial featuring two children protecting a birds' nest from a dog.
Paris, France, 1756-1757
Insc.: "DU N.° 1 — 70m-1.-3g", "1", "3", "FAIT PAR F.T. GERMAIN SCULPR ORFRE DU ROY AUX GALLERIES DU LOUVRE A PARIS 1757"; "DU N.° 3 — 70m", "1", "3", "FAIT PAR F.T. GERMAIN SCULPR ORFRE DU ROY AUX GALLERIES DU LOUVRE A PARIS 1757"
Silver
30 x 50 x 25.5 cm; (tureen); 10 x 58.4 x 43 cm (stand), inv. 5352 and 5353

Maria I
(1734–1816)

Who was Maria I? In Portugal, they called her Maria the Pious. However, when she had to flee to Brazil, she became known to everyone as Maria the Mad. In 1760, at the age of twenty-six, she married her uncle, Pedro (1717–1786), her father's younger brother. Her husband, seventeen years older than her, would become King Consort with the name of Pedro III. Ugly, with a distracted air and a wig that was permanently askew, he looked like a sacristan.

On 13 May 1777 the gallery, three hundred metres long and thirty wide, was ready for the ceremony of popular acclamation of the new queen. The construction was "magnificently furnished with tapestries and damasks and adorned with golden frills and lacework". Crowds of people had gathered during the night, singing and dancing till dawn. Another crowd of spectators gathered on the river, where they waited for Maria's arrival in a flotilla of small boats. At four o'clock, a procession of nobles, senior clerics and the secretaries of state set out. Only then did Maria's two children, Prince José (1761–1788) and Prince João (1767–1826), arrive, accompanied by the Prince Consort and his entourage. Pedro was wearing a large hat decorated with white feathers, an orange-striped cloak and a solid gold sword. Maria arrived last, surrounded by her ladies in waiting. The spectators noted the magnificence of her attire: a silk taffeta gown interwoven with silk thread and studded with diamonds, with a bodice encrusted with precious stones set within a floral pattern. Her train was made of gold-woven fabric and the vermilion cloak she wore, known as the cloak of state, was embroidered with gold and silver thread. To the music of the royal band, the procession entered the gallery, and the royal family took their places beneath a silk canopy. Maria knelt on a crimson cushion and promised to rule Portugal well, preserving justice and the customs and freedoms of her people. Her children and other family members paid homage, the courtiers swore faithful allegiance, and she was acclaimed Queen by the Royal Standard Holder. Trumpets blared and cannons went off, and the crowd shouted, "Long live the Queen!" The Duke of Châtelet, however, who was among the crowd in the Praça do Comércio, noted that "the queen alone did not seem to take part in the general joyfulness, indeed she looked sorely tried". For everyone, she was the Queen of the United Kingdom of Portugal, Brazil and the Algarves, of every side of the sea in Africa, the Duchess of Guinea and of conquest, navigation and trade in Ethiopia, Arabia, Persia and India by the grace of God. According to court ceremonial, Pedro was subordinate to his wife and had to walk on her left, sign his name beneath hers and had no right to the throne. Yet this extremely gloomy man would exercise a powerful influence over Maria, who had held her uncle in great respect ever since she was a child. What's more, when she baulked at his advice, Pedro would start crying and crouch down in a corner of the room wrapped in his cloak, declaring that he would allow himself to starve to death. Though she knew he would not do it, she was aware how heavily it weighed on him that he had no power and she often acceded to his wishes.

In fact, partly due to the laziness of the sovereign and her desire not to offend the memory of her father by dismantling his reforms, there were no great changes. The Marquis of Pombal, the prime minister who had exerted so much influence over José I, modernizing Portugal and expelling the Jesuits, had already tendered his resignation upon the death of the king, though he had not received an answer. Maria believed that the nobles who had taken part in the conspiracy which led to the injury of her father were basically innocent, and had them released from jail, restoring their lost assets and privileges. She could not however accept their request to punish Pombal without undermining the image of her father, to whom she had

Page 75
Giuseppe Troni (attrib., 1739-1810)
Maria I, *18th century*
Oil on canvas
Gripsholms Castle, Mariefred

been very close. It pained her greatly that she found herself unable to make a choice. When the minister requested permission to retire to the provincial city whose title he had assumed, Pombal, Maria consulted with her mother, Mariana, who replied: "I suppose he must be dismissed, given that everyone thinks he should be". But fearing that, through his personality, Pombal might manage to persuade her daughter that he was indispensable, she offered the following counsel: "Avoid seeing him, even just once, on business." At that point the minister was given permission, indeed ordered, to remain in his chosen exile. The enthusiasm that greeted Maria's ascent to the throne stemmed from a convergence of hopes that would be fulfilled only in part. Both the clergy and the nobility were convinced they would regain their power, and the people saw her as a gift from heaven. But the queen never fully settled scores and many members of the previous government, associated with Pombal and the spirit of the Enlightenment, remained in post. Likewise, the Jesuits were never recalled to Portugal, much to the relief of the monks, who detested them. Nevertheless, the monks were in turn subjected to rigorous reform in an attempt to stamp out the scandalous lifestyle that many of them led.

The queen had a gentle gaze in a pale face; she was not small like her mother, but like her was prone to putting on weight. Despite her nervous disposition, she was, like her parents, passionate about horse riding and hunting. When her sister Doroteia died in 1771, she went out to hunt deer and wild boar as soon as the period of mourning was over. Though married, she continued to regret not having entered a convent. She loved sacred music and was mistrustful of balls and the opera. The sovereigns led a secluded life and rarely appeared in public, much to the disappointment of the English writer William Beckford, in voluntary exile in Portugal to escape the furore caused by a homosexual affair in which he had been involved. Only a religious ceremony or

fireworks organized in honour of some saint or other could flush them out. He described them as genuine idols as they alighted from gold carriages studded with diamonds, gazing with benevolent short-sightedness at the kneeling dignitaries and the elated people. Their awkwardness made them look like big children dragged to a reception. The queen, who had put on lots of weight, benevolently shook her fan towards the crowd, while her husband seemed to be snoozing beneath a cocked hat lowered over his eyes. Behind them were their two children. José, the Prince of Brazil and heir to the throne, stood out. Tall and infinitely clumsy and sad, he had married his aunt, who was fifteen years older.

When the royal family accepted an invitation to take some refreshment at the home of a courtier, only Maria I and her immediate family had the right to sit down; the ladies sat on the floor with their legs crossed, while the courtiers, Beckford observed, knelt at the feet of the princesses in abject devotion. In the meantime, the queen's two sons walked up and down yawning with their hands in their pockets. The grandeur of Queluz Palace's decoration, executed at the wishes of the ruling consort, contrasted with the slow and tedious court atmosphere. It was the work of a French artist, Jean-Baptiste Pillement, who had turned down the title of royal painter and gave supreme expression to the Rococo spirit. His frescoes transformed the dining room into a virgin forest, a boudoir into a conference of monkeys.

The reduction of the duty on dried fish had increased the popularity of the House of Braganza among the people, but while demonstrations of affection would move the queen to tears, the Prince of Brazil remained cold and surly amid the "hurrahs" coming from every direction. Maria I was extremely charitable and distributed her aid "with rare grace and dignity" to the immense crowds of beggars who would wait days on end for her to pass by.

Page 77
Bodice ornament belonging first to Mariana and then to Maria I and Maria Bárbara
Spain, mid-18th century; Portugal, 1944-1951 (tassel)
Emeralds, diamonds, silver, silver-gilt
19.0 x 12.4 x 4.0 cm (total size with the tassel), inv. 4779

Unfortunately, her piety made her particularly susceptible to the superstitions of the clergy; when the hereditary prince was struck down with smallpox, the British ambassador rushed to warn the queen: "The prince needs to be vaccinated; it is something we have been doing with the utmost success since Lady Montague brought the secret back from Turkey." "What?" a confessor protested, "do we want to damn our prince by making him swallow the remedies of infidels prepared by heretics?" "Rather heaven!" the queen replied. "Exactly, my lady, the ways of providence must not be opposed: the prince may always be saved by a miracle." The only result was that the prince soon died, to the profound grief of his mother, who felt responsible for his death. When her old confessor, who had been able to calm her anxieties, died, a new and extremely devout confessor arrived to replace him. So, for example, to expunge the sacrilege committed when a thief stole from a church, the queen, concealed by a black veil and with a candle in her hand, walked barefoot through the streets of Lisbon singing the Miserere, followed by her ladies in waiting dressed in the same manner.

Despite her austerity, Maria followed a vogue that was widespread among the Portuguese aristocracy, surrounding herself and playing with black children. Her favourite was Roza, a black dwarf, who had a flat nose and large lips. The queen made her wear bright colours that accentuated her deformity and blackness. The dwarf and the queen were inseparable: Roza had a room near Maria's and the queen showered her with gifts, clothes and shoes. When she died in 1790, the queen offered two hundred Masses in her honour. Nonetheless, amid such extravagances, Portugal had returned to a policy of neutrality, which had greatly helped trade and the wellbeing of its citizens. However, the French Revolution struck fear into the royals, and everyone began to cast suspicious eyes even on the French tutors and servants who had worked for them

for years. This mistrust also extended to the waiting staff of other nations, feared to be French agitators in disguise. All foreigners were viewed with suspicion and even French nobles who had emigrated to escape the guillotine were closely watched out of fear that they might be instigators; and many of these refugees were confined to camps far away from the city. In Porto, the magistrates prohibited foreigners of every rank from settling in their jurisdiction. Not even the priests escaped this climate, though the magistrates and police were more tolerant towards them. The chaplain of the Swedish embassy did note though how bland the measures were to obstruct the spread of subversive books, which were regularly smuggled into the country and which everyone could read and own without risk of consequences.

The incipient madness that overcame the queen upon the death of her husband and son and then of Luís XVI slowly turned to total delirium. Maria stopped washing and combing her hair and would frighten her maids by unexpectedly shouting, "Help me, Jesus!" The only thing that seemed to calm her was playing with pygmies from Angola. This, however, tended to be only a temporary calm, because after embracing them tenderly, she would have them punished because they were not baptized. In rare moments of lucidity, she convinced herself that she was irremediably damned and that any attempt at expiation was therefore pointless. Consequently, she stuffed herself with cakes and used obscene language. Not even the confessors and priests were able to keep her madness in check anymore. One morning, the queen turned up at the council in a dishevelled state after a troubled night: "My father José appeared to me in the horrible guise of a statue of ash and charcoal, standing on a melting metal plinth, while terrible ghosts dragged him down into hell." Her advisers explained that it was Pombal, the anti-Christ, who wanted her lord to join him in hell. At that point, the queen began shouting again: "My father is damned!

I have let my son die and I will be damned too, poor me!" The only moments of calm were offered by a ceremony that slightly differed from the others and by the bizarre generosity with which she distributed money and pensions to heretics who converted.

When the royal family had to seek refuge in Brazil to escape the Napoleonic army, Maria I went too, but yelled for the whole voyage, obsessed by the idea that her servants wanted to torture and rob her. She would only die many years later, in 1816, at the age of eighty-two. She was buried in the basilica of Estrela, which she had had built many years before.

Page 81
Giuseppe Troni
Carlota Joaquina of Spain, *1787*
Oil on canvas
The Prado Museum, Madrid

Page 82
Giuseppe Troni
Carlota Joaquina of Spain, *1785*
Oil on canvas
Soares dos Reis National Museum, Porto

Page 83
Pair of rings with miniatures of Prince João and Princess Carlota Joaquina, with case
Lisbon, Portugal, Late 18th century
Diamonds, painted ivory, glass, gold, silver (rings)
Leather, wood, silk, metal, gold leaf (case)
2.4 x 2.1 x 2.9 cm (rings); 3.4 x 6.2 x 4.5 cm (case); inv. 56637, 56638, 56638/A

Carlota Joaquina of Spain (1775–1830)

Carlota became uglier and uglier as she grew up, but also high-spirited and mischievous. Not even the Spanish court's strict rules of etiquette succeeded in containing the lively vivacity of Carlota Joaquina, daughter of King Carlos IV of Spain (1748–1819) and Maria Luisa of Parma (1751–1819). Before deciding whether to choose her as her daughter-in-law, Maria I of Portugal subjected Carlota to a series of tests before the Spanish court and the Portuguese ambassadors. The results were excellent: the candidate displayed an unusually high level of education for her ten years of age, was quick to respond and had a prodigious memory. This character profile was in marked contrast to that of her dozy betrothed, but the Queen of Portugal was satisfied. Naturally, given the bride's age, the marriage would only be consummated in 1790, when Carlota would presumably become fertile.

The princess arrived with a theologian, an Irish lady in waiting, Emilia O'Dempsy, and a personal maid, Anna Miquelina. Maria I, who waited for her in the royal palace, was disconcerted by the girl's small size and disagreeable appearance. However, she wrote to her Spanish uncle that Carlota was "so very pretty and lively and adult for her age". The life of the Portuguese court, dominated as it was by the clergy, was more sombre and austere than the Spanish one: even Mariana Vitoria did not hesitate to describe it as boring. While Carlota's entourage escorted Mariana Vitoria (1768–1788), Maria's eldest daughter, towards Aranjuez to meet her husband-to-be Infante Gabriel of Spain (1752–1788), the son of King Carlos III of Spain and Maria Amalia of Saxony, the celebrations at court continued for three days. However, the people seemed dissatisfied by the exchange of princesses between Portugal and Spain, muttering that "we have handed over a fully grown fish for a sardine". João, who was eight years older than Carlota, felt

Page 85

David Ambrósio Pollet (attrib.)
Breast Star of the Three Military Orders
Lisbon, Portugal, 1789
Diamonds, rubies, spinels, garnets, emeralds,
silver, gold
13 x 12.2 x 2.2 cm, inv. 4777

Page 86

David Ambrósio Pollet (attrib.)
Small Badge of the Three Military Orders
Lisbon, Portugal, ca. 1790
Diamonds, rubies, emeralds, silver, gold
5,4 x 3.1 x 1.1 cm, inv. 4772

Page 87

David Ambrósio Pollet (attrib.)
Large Badge of the Three Military Orders
Lisbon, Portugal, ca. 1790
Diamonds, rubies, garnets, chrysoberyls,
emeralds, silver, gold
16 x 10.2 x 2 cm, inv. 4784

Mariana's absence keenly as they were very close: "I miss you a lot… I cry every time I pass the door of your bedroom because I am reminded of our long conversations." Feeling isolated in a strange environment, Carlota, or rather her body, reacted with an on-going haemorrhage. But she soon recovered and returned to her usual decisive and rebellious self. She did not want to get up and dressed in the mornings and would complain about everything, from how uncomfortable her shoes were to the fit of her corsets. At the dinner table, she ate with her hands and took pleasure in throwing food at her husband. The unassuming João was perplexed by this strange behaviour. Carlota was "very uninhibited, without the slightest shame" but, he had to concede, "she is very intelligent and has a lot of good sense for one still so young".

Eventually, the queen personally intervened and managed to calm the little rebel down by threatening not to let her ride her donkeys any more or to explore the park of Queluz in a pony-drawn carriage. To distract her, she took her on long horse rides, visiting her favourite convents. The queen herself taught Carlota to speak Portuguese, but the hard work of taming the undisciplined girl brought on a strong conjunctivitis that obliged her to stop making public appearances.

In the meantime, João was chomping at the bit and complained to his sister: "It will be many years before I can go to her, and this upsets me. There is no pleasure for now, because she is so young and her body so small, but the moment will come when I can play with her. How happy I will be then!" But everything seemed to go against his desires. The princess's head had been invaded by a stubbornly resistant colony of headlice, and it had been necessary to shave her hair off, leaving just a single tuft sticking out from a cap. In an effort to entertain her, João went to her rooms twice a day and would kneel down on all fours "playing the donkey for her amusement" and allowing himself to be ridden by her. Unfortunately, and despite his willingness, her amusement was lessened by his bad habit, inherited from his grandfather, of leaving his mouth "open a bit".

In the meantime, suspicion was mounting that Carlota was unable to conceive. The French ambassador, the Marquis of Bombelles, described her contemptuously as "an embryo", destined to bring "further bad blood" to a family drained by marriages between blood relatives. According to his sources, João was "angry about having to resign himself to marrying this stunted princess, this little spider monkey". The British ambassador, Walpole, after noting the prince's possible antipathy towards his wife, hypothesized that their marriage might be annulled, as had happened to the queen mother, Mariana Vitoria, who had been sent back by Luís XV and who later married King José. In the spring of 1790, however, Carlota's periods began, much to the satisfaction of the royals and the court. Their first night together was brought forward, partly due to the groom's impatience. "Our beloved Carlota", Maria I wrote to Carlota's mother, "has reached full maturity without the slightest problem… Even before this, I had intended to have them meet, even if just for a short while, given that she was so well informed about everything, and João was so eager for conjugal relations. I have no further doubts now. It will happen at Easter, and I am very happy."

When the moment finally came, the queen personally helped the maids to undress Carlota and get her into the marriage bed. The morning after she communicated to Maria Luisa: "Our beloved Carlota joined with her husband yesterday. They spent a good night together and are very happy." The happiness was short-lived, given Carlota's open contempt for her placid husband. The "shrew of Queluz", as her enemies called her, had the "most bizarrely ugly" face in the world. Her small eyes, a little cross-eyed, looked at people ironically or dismissively. Her nose was red and swollen, her blackish, crooked teeth were a mess, and her skin dotted with spots. She had dark, ungraceful hands, bony arms

Maria Leopoldina of Habsburg-Lorraine
(1797–1826)

A strange girl was growing up at the Viennese court: the daughter of Emperor Francis, Maria Leopoldina lived as far away as possible from receptions, games and gossip. Educated by her grandfather, Leopold II (1747–1792), according to Enlightenment values, at the age of nine she wrote down several precepts: "Do not oppress the poor. Be charitable. Do not complain about what God has given you but improve your habits. We must strive earnestly to be good." Her mother died a year later, deepening her sense of solitude. Fortunately, her stepmother, Maria Ludovika of Este (1787–1816) was very affectionate and attentive to the upbringing of Maria Leopoldina and her sister Maria Luisa (1791–1847), Napoleon's future wife. When Maria Ludovika also died, in 1816, Maria Leopoldina wrote: "Everything I am I owe to her". The young archduchess's mood was remarkable, swinging between cheerfulness and melancholy, but she never lost her extraordinary strength of will. Maria Leopoldina remained a silent presence as she grew up, with little interest in pomp and court events. Sensitive by nature, she assumed a reserved, courteous air so as not to let her emotions show. She was interested in the natural sciences, botany and mineralogy. She gathered new precepts for herself in a notebook that she always kept on her person: "Keep sensational dress away from me. Let my heart remain eternally closed to the corrupting spirit of the world. Let harmful luxury, unseemly finery, ambiguities and scandalous dresses also remain far from me … Let modesty always be my indispensable virtue, to preserve the purity of my heart. … I will always regard lying as the Devil's work and the plague of society."
At the age of nineteen, she was already considered old for the marriage market, which preferred younger girls more likely to reproduce. Her father the emperor joked about this sore point, saying that he would appoint her to be the court mineralogist. But then, with the support of Metternich, came a proposal from a prince who had knocked in vain on the doors of every royal palace in Europe. An air of scandal surrounded the candidacy of Pedro of Portugal: not only was he known to be epileptic, but he was also unable to curb attacks of rage that led him to beat both men and animals. As if that were not enough, he was convinced that all women, commoners and ladies alike, were at his disposal.
In the end though, and obviously without consulting his daughter, Francis I decided to accept Pedro's proposal. The romantic Leopoldina needed nothing more than to see a portrait of her future husband to fall in love with a stranger, who seemed to her to be an Adonis.
After the marriage by proxy, Leopoldina drew up a new list of principles which were to serve as inspiration for the new life that awaited her: "1) to restrain my vehemence, to be good to the servants, so as to become accustomed to being gentle and malleable; 2) to shun any impure thought, because as from today I belong to my husband; 3) I will undertake to work diligently at my education; 4) I will endeavour to speak always with complete sincerity."
When Leopoldina arrived in Rio de Janeiro, after a three-month voyage during which she suffered terribly from sea sickness, she finally met her husband. He was a tall young man with a face scarred by smallpox (frequent at the time), but she found him very attractive all the same. The nuptials were celebrated with great pomp and ceremony. Leopoldina arrived on a galley rowed by a hundred oarsmen and passed under a dazzling arch of triumph built especially for the occasion, to loud applause from the people and the boom of cannons. She was accompanied to the altar by her father-in-law, João VI, who was immediately appreciative of the fragile, fair-haired girl and had the rooms of the new couple expensively furnished

Page 92
Jean-Baptiste Claude Odiot
Jewelry box
Paris, France, 1817
Insc.: "J.B.te C.de / ODIOT"
Silver, silver-gilt, silk
19.3 x 18.2 x 10.3 cm, inv. 4856

with fashionable items from the Jacob furniture manufactory.

Leopoldina's husband soon turned out to be not the slightest bit accommodating. He took his wife to visit his lover at the time, a French ballerina who bore him a child. Irritated by this behaviour, his father had the French woman removed from Rio to avoid his son's marriage being compromised. However, it took much more than this incident to discourage the determined archduchess.

Pedro was fond of his father, but he hated his mother, Carlota Joaquina, who he publicly called "the whore" due to her innumerable adulteries and the humiliation suffered by his father. Neglected by his parents, his governess and tutor alone had given him the semblance of a family. For this reason, he had studied many subjects in a rough and ready fashion, ranging from geography to economics, and had just a smattering of French, German and English. He would, nevertheless, continue to study for at least two hours a day throughout his life.

A skilled horseman, capable of breaking even the most intractable steeds, he also had a fine voice and played various instruments, including the violin and the flute. He had had a workshop built where he carved wood and did blacksmithing. Impetuous and fickle, he divided his time between hunting expeditions and amorous adventures in the seedy districts of the city, where he dressed as a commoner. Pedro, nonetheless, had other qualities. Attentive to his personal hygiene, he dressed modestly – white cotton trousers, a striped cotton jacket and a wide straw hat – and was always ready to converse with passers-by to learn more about their problems. Leopoldina tolerated her husband's frequent dalliances but was soon faced by a more serious problem. The Junoesque Domitilla de Castro (1797–1867), who Pedro had met a year before Leopoldina's arrival, was proving to be an increasingly awkward presence. Not content with having made her first a viscountess and then marchioness of Santos, he showed her

off at court and insisted on appointing her as his wife's lady in waiting. The courtiers soon learnt that anyone who wanted something from the sovereign would do better to turn to his lover rather than his legitimate consort. Leopoldina's efforts to curb the impetuous Domitilla were met with physical violence and furious scenes. Everyone was aware of what was going on and the young Austrian, surrounded by gossip about the unfortunate situation, consoled herself by studying the country's luxuriant nature and vegetation, sending drawings and exemplars to Vienna.

As if the three daughters he had with Domitilla were not enough, Pedro also had a child with a sister of his lover, and another one with a new conquest. These illegitimate children were all legitimized, and as was the custom in the House of Braganza, they all received noble titles. Leopoldina was also forced to bring them up together with her own: she had seven children, three of whom did not survive. She put up with all these humiliations in the hope that she would soon be able to return to Portugal and put the outrageous goings-on behind her. In addition to all this, she also had financial difficulties. Pedro, who showered gifts on Domitilla, systematically deprived her of her income. The delivery of her first child, Maria da Glória, had been extremely painful, as she confided in a letter to her sister. Afflicted by terrible headaches and sudden sweats, Leopoldina led a reclusive life and devoted herself to charitable works. But in the autumn of 1826, she asked her husband in exasperation to publicly choose between her and his favourite. When Pedro returned home, he found his baggage waiting for him in front of the door and a violent quarrel ensued.

Even more violent were the ructions in the Brazilian colony, keen to shake off the antiquated Portuguese monarchy. In this difficult context, and despite his intemperance, Pedro placed great faith in Leopoldina's intelligence. He trusted her judgement, and after various phases of uncertainty, accepted the plan

for a constitutional monarchy and was proclaimed Emperor of Brazil, much to the displeasure of his father, who refused to recognize it. When João VI died in 1826, Pedro found himself with two roles at the same time: he was King of Portugal as Pedro IV and the Emperor as Pedro I. This paradoxical situation was resolved a few months later, when he abdicated from the Portuguese throne in favour of his seven-year-old daughter, Maria.

Pedro's political victories, however, did not mollify him, and he continued to beat and humiliate his wife, who, exhausted, wrote to her sister Maria Luisa: "Listen at least to the cry of pain of a victim… who asks not for revenge but pity". There are various versions of the empress's precocious death at the age of twenty-nine. According to Count Rodolphe Apponyi, the Austrian ambassador to Paris, Leopoldina, who was close to giving birth, had a foreboding and begged her husband, who she continued to call "my darling Pedro", not to leave her. When she was unable to convince him to stay, she burst into tears: "As you are leaving me in my final hour, allow me to bid you farewell for ever. We will not see each other again in this world." But, reassured by the doctors, he left to go and fight in Portugal. She succumbed to an attack of "bilious" fever after losing her child.

According to others, her death was provoked by the emperor, said to have kicked her in the stomach during a terrible quarrel at which his lover Domitilla was also present. This, at least, was the rumour that began to spread in Brazil, discrediting the emperor.

But Leopoldina's influence lived on, and indeed it became stronger than ever. After belatedly acknowledging the virtues of his good, honest and patient wife, the emperor began to feel her absence. One day his lover found him sitting on the floor with his face streaked with tears and a portrait of the empress in his hands. Then he walked out of Domitilla's bedroom, shouting: "Leave me alone! I know I lead a life unbefitting that of a king. I always think of the empress." The marchioness was soon expelled from court, then recalled before subsequently being exiled for good. Pedro tried to behave better and began to look after his children, who he felt he had deprived of their mother. In this sad period of mourning, he wrote to his father-in-law, Francis I of Austria. "All my weaknesses have disappeared. I will not fall into the same errors, which I regret and for which I ask God's forgiveness."

Amélie of Leuchtenberg (1812–1873)

"She has a body similar to the one given to the Queen of Sheba by Correggio in his paintings", the envoy to the Emperor of Brazil wrote with enthusiasm about Amelia of Leuchtenberg. The granddaughter of Joséphine de Beauharnais, Napoleon's first empress, Amélie was not just rich but also, according to the *London Times*, one of the most refined princesses in Germany. Moreover, up until that point, all the other possible candidates had firmly turned down the irascible, abusive and unfaithful emperor's proposal of marriage. Only Amélie of Leuchtenberg, the third daughter of Eugène de Beauharnais (1781–1824) and Augusta of Bavaria (1788–1851), had the courage to accept. The frigate *Imperatriz* arrived in Rio de Janeiro well ahead of time on 15 October 1829. Pedro I went out to meet her in a tug, as per tradition, and was struck by the beauty of his betrothed. Among those accompanying Amélie to Brazil was her brother, Auguste de Beauharnais (1810–1835), a striking figure with handsome good looks and an air of distinction, who later married Maria da Glória (1819–1853), the emperor's daughter and candidate for the throne of Portugal.

The ladies at court were very appreciative of Amélie's long white gown, worn under a silver-embroidered cloak. The nuptials were celebrated in great style with processions, banquets and fireworks. At the ceremony to present the new sovereign to court, all the Brazilian ladies wore pink in her honour. The new union was sealed with a honeymoon lasting more than a month. Amélie's strong personality emerged straightaway when she refused to receive one of her husband's illegitimate daughters and had her packed off to college in Switzerland. The emperor was very keen that his descendants should be well educated: "I want my brother Miguel and me to be the last of the Braganzas to receive an inadequate education." In the meantime, Amélie, without allowing herself to be downcast by the disorder and provincialism of the Brazilian court, adopted French as the official language and set about renewing the clothing and accessories of the ladies. Pedro I's son also appreciated this breath of fresh air. The empress personally supervised his studies and the future emperor, anxious for affection, became so fond of her that he called her mummy.

Amélie's husband expressed his satisfaction by giving her the famous Braganza diadem, no less than 12.5 cm high. "The diadem", wrote the empress, "is made of Brazilian diamonds of various cuts, so pure they look as if they are made of water". However, a worrying economic and political crisis prompted Pedro to abdicate in favour of his five-year-old son. Another motive also forced him to cross the Atlantic though – his brother Miguel had usurped the kingdom of Portugal. For her part, Amélie was happy to get her husband away from a palace where everyone talked to her about a past that she preferred to forget.

At the ceremony of abdication that took place on the second floor of the palace, the imperial family lined up together with the ministers. Little Pedro stood on a chair, so he was clearly visible to the throng. Fair-haired, pale and with the clear blue eyes of the Habsburgs, he waved a handkerchief towards the crowd.

The voyage towards Europe was particularly hard for Amélie, who was pregnant and felt sick for much of the time. After a stop at the Azores, which had remained faithful to the ex-emperor Pedro, who was travelling under the title of Duke of Braganza, Amélie went to Paris with Maria da Glória. It was there she gave birth to Maria Amélia of Brazil (1831–1853). Her husband wrote to her enthusiastically that "Providence wished to diminish the sadness felt by my paternal heart due to the separation."

The Duchess of Braganza only definitively joined her husband in Lisbon when her brother-in-law, Miguel, despite his great popularity among the Portuguese, had been defeated and exiled. Worn down by a

gruelling war, Pedro died of tuberculosis in 1834, leaving bequests to his illegitimate children in his will, thereby significantly reducing the inheritance of Amélie and her daughter. In his final days, he sent a message to his Brazilian subjects: "Slavery is an evil, and an attack against the rights and dignity of the human species, but its consequences are less harmful to those who suffer in captivity than to the nation whose laws allow slavery. It is a cancer that devours its morality."

Amélie did not remarry, preferring instead to devote herself to charitable causes and bringing up her daughter, who had a great talent for music. Sadly, the girl, promised to the Archduke Maximilian of Habsburg-Lorraine (1832–1867), died of tuberculosis in 1853. Amélie followed her twenty years later. Maximilian, who the queen "would have been happy to have as a son-in-law if God had let her beloved daughter live", and having become Emperor of Mexico, was shot by rebels in 1867.

Maria II
(1819–1853)

Maria II, also known as Maria da Glória, was just seven years old when her father, Pedro IV of Portugal (and 1st Emperor of Brazil), abdicated in her favour, definitively separating the two crowns. In the hope, which soon proved illusory, of avoiding disorder in Portugal, Pedro decided to offer his daughter's hand in marriage to his brother, Miguel (1802–1866), who would then act as regent until Maria came of age. It was a seemingly perfect solution, but the widespread popularity enjoyed by Miguel, who had the support of the people and some sections of the aristocracy, prompted him to renege on his brother's proposal immediately after accepting it.

Egged on by the ambitious Carlota Joaquina, the handsome, impetuous and absolutist Miguel publicly burnt the constitution he had pledged to defend and proclaimed himself king. Pedro was furious and, abdicating from the throne of Brazil in favour of his son Pedro II (1825–1891), he set sail to cross the ocean and remove the usurper. Before leaving to restore order in Portugal, the ex-emperor knelt before his emotional daughter and solemnly declared: "My Lady, before you is a Portuguese general who will ensure your rights are respected and will restore the crown."

It was a costly civil war but, in the end, at the age of fifteen, Maria ascended the throne. She was an attractive adolescent with a proud air, dazzling eyes and a pale complexion. She was described by those who knew her as "passionate", a trait confirmed by a portrait of the adolescent painted in 1829 by Thomas Lawrence. Her first, much loved husband, Auguste, Duke of Leuchtenberg, the son of Eugène de Beauharnais (1781–1824) and Augusta of Bavaria (1788–1851), died just two months after their marriage, leaving a "widow who had never been a wife". Compounding the queen's personal grief was concern for the instability of the political situation, which demanded a male

presence at her side. The choice fell on the handsome Ferdinand of Saxe-Coburg and Gotha (1816–1885), but according to Portuguese law he had to wait until their first child was born to become king consort with the name of Ferdinand II. Vitoria of Kent (1819–1901), the future Queen of England, commented with enthusiasm on the marriage: "I cannot say how happy I am to be related to the Queen of Portugal, who has always been so kind to me and for whom I have always had great affection. She is good, honest and affectionate, and is most pleasing when she speaks. We have known each other since the age of eight (because there is just one month between us)… she has an exquisite complexion, a beautiful nose and fine hair. I have heard that Ferdinand is full of fine and excellent qualities, has a pure and unsophisticated mind and is very handsome."

Initially viewed with mistrust by the Portuguese, Ferdinand, though he was not at all ambitious, proved equal to the difficult situation: Maria II experienced fourteen insurrections in fifteen years during her reign. A cousin of Queen Vitoria, Ferdinand accompanied his wife to England in the period when the war with Miguel forced them into exile. During a party held at Windsor by William IV, the guests admired the elegance of Maria, decorated "with all the ribbons and orders". A small accident, when the queen fell and hurt her forehead during a ball, gave the English court and Vitoria occasion to appreciate Ferdinand's delicacy and devotion.

An amateur painter, a lover of the arts and of music in particular, his influence was behind the fairy tale-like Pena Palace on the hills of Sintra, a triumph of nineteenth-century eclecticism in which highly disparate styles, from Moorish to Vitorian, coexisted splendidly.

In the meantime, the life of the royal family continued to run its placid course. However, the members of the imperial family of Brazil were considered strangers and, as such, they always had to give way to the Portuguese royals, a norm that deeply hurt the empress, who preferred to keep away from the Portuguese court. One visitor observed with amazement the rules governing the moment when the courtiers were received. The ladies sat in a circle in a large room; the men remained standing and moved around freely behind them, conversing among themselves. The king and queen sat on a sofa in an adjoining room with the doors open. The queen never stood up and never spoke to anyone. The king, on the other hand, moved around the room every now and then to pay tribute to some of the ladies or to talk to members of the diplomatic corps. Having completed these little sorties, he returned to the queen, giving her affectionate pats on her plump thighs or shoulders. The queen responded with a graceful smile and a few little touches "in poor taste".

In 1853, an extremely difficult childbirth sapped the strength of the queen, already exhausted by ten pregnancies. Her doctors warned her of the danger, but in vain. "If I die, I will die in my place", Maria replied. The new-born child, who would not survive, was baptized before being extracted from his mother's womb. She calmly said to her doctor: "If I am in danger, tell me, do not deceive me." Then she bid farewell, saying: "I hand over my soul to God."

Sixteen years after the death of his wife, in 1869, Ferdinand II married again. His bride was Elise Hensler (1836-1929), an opera singer. He left her the Pena Palace, in Sintra that, in 1889, returned to the Portuguese state.

Page 110
Thomas Lawrence (1769-1830)
Maria II, ca. 1830
Oil on canvas
Queluz National Palace

Page 111
José Rosas Junior
Breast Star of the Military Order of the Tower and Sword
Portugal, 1949
Insc.: "RESTAURADO | Alexandre Silva | em 6-5-949 | e | José Rosas & Comp. | R."
Diamonds, rubies, emeralds, silver, gold, enamel
12 x 11.4 x 2.6 cm, inv. 4783
Replica of the original insignia, crafted in 1808-1809 and disassembled in the second half of the 19th century

Page 112
William Clutton & David Cox for Storr & Mortimer (1822-1839)
Sceptre
London, UK, 1828-1829
Insc.: "CARTA | CONSTITUCIONAL.: .. SENHORA D. MARIA II | OS PORTUGUEZES LEAES | MCCCXXVIII | LONDRES": monograma coroado "MMII"; "STORR & MORTIMER"
Gold
66.5 x 4.8 cm, inv. 4870
Offered to Queen Maria II, in 1831, by exiled Liberals in London

Page 113
William Simpson (attrib., 1801-1900)
Maria II, ca. 1837
Oil on canvas
Imperial Museum, Petropolis

* Braganza of Brazil. With no connections to the Portuguese Royal Treasure.

Page 114
Teresa Cristina of Bourbon
Oil on canvas
Private Collection

Pages 115 and 116 (detail)
Writing Desk
Brazil or Portugal, 1st quarter of the 19th century
Gold, diamonds, rubies, ivory, parchment, glass, silver
24.5 x 22.5 x 15.5 cm, inv. 4853

Teresa Cristina of Bourbon* (1822–1889)

Two shocks left a lasting mark on the life of Pedro II of Brazil. The first came when he was five years old. The morning after his coronation, which was brought forward in the hope of calming the unrest in the country, he woke up alone. His parents and sister had left for Europe without saying goodbye, and a sense of inadequacy and solitude would long accompany his career as monarch.

The second came as an even greater surprise. In March 1843, he watched as the small fleet escorting his betrothed from Naples to Rio de Janeiro appeared on the horizon. For a week, he had been unable to sleep for excitement. When he had been shown a portrait of his bride-to-be, a dark-haired, delicate beauty, he had had no hesitation – she was perfect. That is why he did not wait for the ships to enter the port, but rushed to meet her in his boat. But when Pedro, tall, fair-haired and handsome, with blue eyes and the unmistakeable jutting jaw of the Habsburgs, saw Teresa Cristina of Bourbon, he was lost for words: there was not the slightest resemblance between the woman in flesh and blood standing before him and the portrait with which he had fallen in love. She was small, fat, unattractive and had a limp; what is more, she looked older than the twenty years she was claimed to be. Though very well-mannered, Pedro was unable to conceal his disappointment, walked away from the nasty surprise and had to sit down to control his emotions.

When they were finally alone, they both cried for a long time and Pedro complained to his governess, who was a second mother to him: "They've deceived me!" After being told about the misleading portrait, Teresa Cristina, who had a resolute character, wrote to her parents: "I know that my appearance is different to how it was presented. I will do everything to live in such a way that no one can be deceived about my character. My ambition will be to be like Dona Leopoldina, my husband's mother, and to be Brazilian with all my heart in everything I do."

It was not easy to convince the young emperor to marry her but, in the end, his courtiers, worried about a possible scandal, managed to win him over. However, time passed and no heirs arrived, and it was rumoured that the sovereign was impotent. In the end, troubled by his wife's pain, who broke down in tears and asked to be sent back to Italy, Pedro decided to consummate the marriage. It was a decision forced upon him and did nothing to alter his persistent coldness towards Teresa Cristina.

The Neapolitan bride had arrived in Brazil in the company of her brother, Luís of Bourbon, Count of Aquila (1828–1897), who fell in love – and it was reciprocated – with his brother-in-law's elder sister, Princess Januária of Braganza (1822–1901). After returning to Naples and obtaining permission from his parents, he crossed the ocean again and married her. The emperor was said to have been irritated by the spontaneous friendship between Teresa Cristina, his brother-in-law and his sister, so very different from the resentful atmosphere of his own married life. The courtiers played on this, putting it into his head that the Count of Aquila had dynastic ambitions regarding the throne of Brazil. A definitive split occurred when Pedro, after much hesitation, gave permission for the count and his sister to return to Italy, leaving the empress even more lonely.

The "silent empress", as she was nicknamed for her discretion, impressed her subjects with the modesty of her attire and her restraint: shunning all ostentation, she only wore jewellery for official ceremonies. Few people were aware of the Greek and Roman antiquities she had taken to Brazil as a gift and which would form the core of the city's future museum. Interested in archaeology, she had had excavations carried out at Veii when she was in Italy. What free time she had left after fulfilling her charitable engagements

and bringing up her daughters was devoted to mosaics, with which she decorated fountains and palaces.

In the meantime, the sovereign's amorous adventures multiplied. His wife found it hard to put up with them, as she was hot-tempered by character and struggled to conceal her vexation. She experienced the greatest affront, however, when Pedro appointed the Countess of Barral first as the governess of the royal couple's two daughters and then as lady in waiting to the empress herself. Beautiful, seductive, refined and lively, the friend of celebrities such as Liszt and Gobineau, she seemed the complete opposite of the sovereign. Though her relationship with Pedro was said to be purely platonic, there was a very embarrassing moment when one of Teresa Cristina's daughters asked their mother why their father kept on stroking the countess's feet during lessons.

Two long trips abroad, which were not welcomed by a woman focussed above all on family life, were followed by an involuntary enforced voyage in 1889, when the republicans came to power following a coup and the Braganzas were exiled. Now elderly, and suffering from a serious form of asthma, the separation caused the empress great affliction. In her final moments, she said: "I die not of illness. I die of sorrow and regret!"

After her death, an immense crowd in Porto paid their respects to the reclusive benefactress. Even the emperor became convinced that his wife had been a saint and would undoubtedly forgive his excesses and watch over him from heaven.

Stephanie of Hohenzollern-Sigmaringen
(1837–1859)

The shortest reign was unquestionably that of Princess Stephanie of Hohenzollern-Sigmaringen. Known as "Estefânia" in Portugal, she married Pedro V of Portugal (1837–1861), who was the same age as her, in 1858. They had met during one of the prince's educational trips through Europe, and straight away Stephanie seemed to him to be the ideal woman, "who understands how to subordinate the material side of relations between man and woman to the sublime and Christian principle of complicity in marriage". The husband of Queen Vitoria, Albert, who he called uncle, had appreciated Pedro's choice of a "Catholic princess, but from a Protestant and liberal family and with completely new blood uncorrupted by the combinations of the Bourbons and the Habsburgs". For her own part, Vitoria admired her young relative: "Pedro is full of resources – passionate about music, drawing, languages, natural history and literature."

From the outset, Pedro's choices were very different to those of his predecessors. Disgusted by the pleasure-loving life of his father and his brother, Luís, he led a more retiring life. In 1857, a year before he married, he wrote: "I lead a hermit's life with my books – the best and most faithful friends in the whole country. My father enjoys himself in a way that I cannot approve or imitate because it is so contrary to my principles."

The handsome, intelligent and well-informed prince concerned himself above all with reforming his kingdom, which was particularly restless at the time. Hostile towards politicians, whom he viewed as scoundrels, he won admiration for his seriousness and the courage he displayed by not leaving Lisbon during successive outbreaks of cholera and yellow fever. The couple devoted a lot of time to charitable works and building hospitals. Despite the undeniable rapport between

Page 117
Karl Ferdinand Sohn (1805-1867)
Stephanie of Hohenzollern-Sigmaringen, *1860*
Oil on canvas, inv. 4046

husband and wife, the marriage was never consummated, which has prompted some scholars to back the idea that the young king was a repressed homosexual. In any case, Pedro suffered greatly following the early death of his wife from diphtheria, and after refusing to remarry, he himself died two years later, perhaps from cholera. Upset by those premature deaths, Queen Vitoria commented: "A terrible calamity for Portugal and a real loss for Europe!... Pedro was so good, so intelligent, so distinct... Everything, everything finished! He is happy now, reunited once again with his beloved Stephanie, from whose loss he never recovered."

Page 119
Luigi Gandolfi (1810-1869)
Maria Pia of Savoy, *1863*
Oil on canvas, inv. 506

Page 120
Adão Gottlieb Pollet (atrib.)
Medallion and couple of pendants
Lisbon, Portugal, 1784 (attrib.)
Blue sapphires (oval 100.05 carats, pear 50-60 carats), diamonds, gold, silver
4.3 x 4,8 x 1.3 cm (medallion); 4.1 x 2,0 x 1.0 cm (pendants), inv. 4782, 4782/A, 4782/B, 4782/C

Page 121
Estêvão de Souza (act.1839-ca.1880)
Necklace
Lisbon, Portugal, 1865
Diamonds, gold
3.9 x 41 x 1.2 cm, inv. 4724

Page 122
Estêvão de Souza (act.1839-ca.1880)
Necklace
Lisbon, Portugal, 1865
Diamonds, gold
3.9 x 41 x 1.2 cm, inv. 4724

Page 123
Musy Padre and Figli
Brooch belonging to Queen Maria Pia
Turin, Italy, 2nd half of the 19th century
Pearls, diamonds, silver, gold
6.4 x 6.1 x 2.1 cm, inv. 569422

Maria Pia of Savoy
(1847–1911)

The fifteen-year-old who disembarked from the royal corvette *Bartolomeu Dias* in Lisbon on 6 October 1862 was small, blonde and very pretty. Maria Pia of Savoy had fabulous eyes and an irresistible smile. She was fearless and confident in the knowledge that she descended from a royal line and was the third Savoy to ascend the throne of Portugal. The young queen, accompanied by a festive procession, entered the glittering pavilion erected for the occasion, where she received the keys of the city. During the three-day celebrations, the city seemed to forget the malaise spreading through Portugal.
In her short life until then, Maria Pia had already had to face some traumatic changes: her mother, Adelaide of Habsburg (1822–1855), had died during childbirth when she was eight and she ended up being dependent on her older sister, Clotilde (1843–1911). She was supervised night and day by her governess, a strict marchioness, and only saw her other three siblings on Sunday. One of them, Umberto (1844–1900), the future King of Italy, had accompanied her on the journey. Her father, Victor Emanuel II (1820–1878), was satisfied with the marriage and granted, at his daughter's request, an amnesty for political prisoners: one of the beneficiaries was Giuseppe Garibaldi, who had been imprisoned following the attempted liberation of Rome. Before leaving Turin, Maria left a large sum of money for the poor. Duke Luís (1838–1889), the son of Maria II and Ferdinand of Saxe-Coburg and Gotha, was eight years older, fair-haired like her, good-looking and a lover of the arts, especially poetry and music. An accomplished piano and cello player, Luís spoke several languages, painted and had apparently translated some of Shakespeare's works. Having served in the navy, he had retained the habit of wearing a glittering admiral's uniform.
The first years of the couple's marriage

were loving and collaborative. Luís then, however, resumed his former lifestyle of amorous dalliances and Maria Pia, profoundly disenchanted, slipped into depression. Nonetheless, this did not stop her personally performing great acts of courage that were very unusual for a woman at the time, and even more so for a queen. Out on a walk one day, she saw two children in danger of drowning in the Tagus and jumped into the river without hesitation to save them. On another occasion, she dashed into the flames of a burning house to rescue its occupants. While Maria Pia remained beautiful, majestic and regal; the passage of time was not kind to the king. Luís, who over-indulged at banquets, became "a fair-haired, lumpy little man who looked rather odd in the admiral's uniform he wore all the time".

Luís and Maria Pia were actually very different. Though the placid king had abolished the death penalty, and was liberal and anticlerical, he did not really address the country's growing economic and political problems. His wife, on the other hand, though aware she could not really influence the situation, devoted herself untiringly to charitable works and helping the children of working mothers unable to look after their offspring.

The quiet musical evenings at the royal palace, for which the queen composed her own pieces and played a number of instruments, were not enough to satisfy her drives. The already delicate balance of the king and queen's marriage was further endangered when, in 1887, Luís began to openly display his relationship with a singer in the Lisbon theatre, Rosa Damasceno. Irritated by the ensuing scandal, the king talked of abdicating, while the queen stopped eating and threatened to leave him and return to Turin. The situation was resolved, at least in practical terms, by the onset of an illness, neurosyphilis, that led to the death of the king two years later. Maria Pia cared for him unflaggingly, looking for new medical cures. At the end of his days,

she took him to see the ocean at Cascais, satisfying his final wish.

Maria Pia had in the meantime reacted to the disappointment of her marriage by taking a series of lovers. This led to a good deal of whispered grumbling, but it did not diminish the affection of the Portuguese for the small, courageous woman with an irresistible smile. They also forgave her some long waits at Mass: she used to delay her arrival until the exact moment when the rays of the sun fell on her kneeler, lighting up her blonde hair.

Tales were also told of the eccentric magnificence with which her rooms were furnished. The carved and gilded tester above her bed was legendary, as was the damask woven through with silver thread on the walls and the white bearskin on the floor. The queen's motto, "I await my star" and that of the Braganzas, "After thee, us", were embroidered on the pink silk drapes that clad the walls of one of the rooms. A kneeling-stool was positioned near an ottoman, and a statue of the king next to a cannon stood out among the white marble sculptures.

Although the queen's expensive tastes often caused difficulties for parliament; unabashed by the protests, Maria Pia would curtly reply: "If you want queens, pay for them". "She was a princess brought up like those of the House of Savoy", her butler recalled. "She was very highly strung, so much so that she could not bear the sound of something dropping on the floor, the slamming of a door, or uncontrolled gestures. She did not wear perfume because it gave her a headache. Those of us who attended her had to be very careful and walk gracefully and respectfully." The queen, however, did not tell them off; and indeed she always smiled when they passed. The trials most feared by the servants were the frequent picnics in the environs of Sintra or on the Estoril beaches. In fact, Maria Pia had no idea of the incredible amount of work required to organize these events. She liked travelling a great deal, but one day, tired of hearing ministers objecting that the coffers were

AMÉLIE·PRINCESS
DE·FRANCE·REINE·
PORTUGAL·A·D·MCM·

empty, she worked it off by going from Lisbon to Sintra on foot.

When Luís I died, the queen came out of his room, pale-faced, and, looking at the courtiers, uttered the time-worn phrase: "The king is dead. Long live the king!" Sadly, that would not come to be, because her son Carlos I (1863–1908) and grandson Luís Filipe(1887–1908) were shot dead in 1908 in an attack that brought the reign of the House of Braganza to a bloody end. Already devastated by the assassination of her brother, King Umberto I, in 1900, she slowly slid into a state of senile dementia. She would, for example, water the flowers of the Aubusson rugs in her rooms and was amazed when she did not see them growing.

Her exile from Portugal, which began when she embarked on the yacht, *Amélia da Ericeira*, together with the rest of the royal family, was a further trial. In the end, she retired to Nichelino, near Turin. In the last moments of her life, in 1911, she asked what direction Portugal was in, so she could look towards it.

Amélia of Orléans
(1865–1951)

Amélia of Orléans was so tall – 1.82 m to be precise – that her family feared they would be unable to find a husband for her. She was born in 1865, in Twickenham, England, where her family had gone into exile after the fall of the king in 1848. After the great fear caused by the Paris Commune in 1871, a law was passed authorizing the return of the presumed heir to the throne, the Count of Paris. It was there that Carlos of Saxe-Coburg and Gotha (1863–1908), then Duke of Braganza, met and became enamoured of her in 1886, much to the relief of the family, worried that she was still unmarried at the age of twenty-one.

The Orléans, enthusiastic about this ideal solution, organized an immense and lavish party at the Hôtel de Matignon, inviting not just prominent figures from European high society but also diplomats, generals, bishops and members of all the royal families of other nations. A month later, the French government, worried by what was seen as an attack on its power by the monarchists, passed a new law prohibiting all pretenders to the throne and their descendants from entering France.

After the wedding, celebrated in style in Lisbon, Amélia quickly realized the gravity of the situation in Portugal, mired in poverty and lacerated by intractable internal conflicts. The willingness of her father-in-law, Luís I, to accept constitutional changes was overtaken by events. When Carlos I ascended the throne in 1889, the queen realized how little popularity he enjoyed and did her best to improve the situation while bringing up their two children.

Amélia's stature was such that it was impossible not to notice her, and she was always ready to intervene to help Portuguese subjects in difficulty, whether it was a new-born child snatched from flames or a fisherman in difficulty saved from the waves. Even when the Spanish flu and smallpox epidemics were raging, the

queen continued to visit the hospitals of Lisbon. Her charitable work ranged from a shelter for the homeless, which fed the unemployed free of charge, to a modern paediatric hospital for poor children. The naturalness with which this proud but simple woman engaged with the people aroused envy and mistrust among the other members of the royal family, and her support for the Jesuits only accentuated this hostility.

As one political crisis followed another, in an increasingly disturbing sequence, the curly-haired young king, who was smaller than his wife and had a certain charm and appeal, seemed to have little concern for anything but his female conquests, in the course of which he later contracted a venereal disease. Once, to seduce a lady at court, he took on a bull with horns that had not been filed down. The republican newspapers took advantage of his excesses to discredit him, arguing that he squandered state funding by showering his lovers with jewellery. The brutality of his prime minister, João Franco, moreover, did nothing to resolve tensions.

Faithful to her role as queen consort, Amélia did not display the jealousy of the rulers who had preceded her. Malicious courtiers, nevertheless, insinuated that the queen was actually incapable of having a lover, unlike the queen mother who had many. Only with time would she learn to appreciate the kindness of heart concealed behind the brusque manner of Maria Pia of Savoy. "Queen Maria Pia", the Duchess of Guise explained, "was adored, and poor Amélia, a true saint, was unable to make herself loved". In contrast with the sobriety of her attire, Amélia's eclectic taste in furnishings resembled Maria Pia's, albeit in a less sumptuous manner. Furniture of every style and epoch coexisted in a disharmonious manner, with an order apparent only to the mistress of the household.

The couple were fond of trips to Paris, where they frequented aristocratic salons and went to the theatre. "His Lotion", as King Carlos was ironically nicknamed by regulars at Maxim's, soon seduced Gabrielle Réjane, an actress greatly admired by Proust. Parisians learnt to recognize the tinkle of the silver bells on the four white mules that pulled an exquisite two-seat carriage, a gift to Réjane from her royal admirer.

Manuel (1889–1932), the brown-haired second son of the Braganzas, also found love in the French capital. Gaby Deslys was a dynamic blonde variety star, who once said to the philosopher Henri Bergson: "With my looks and your brain, we could do anything". Ten years older than Manuel, Gaby was already immensely rich, but her presence alongside Manuel, who was not slow to shower her with gifts of jewellery, to show her off at a charity concert in Lisbon and to instal her in the Necessidades Palace, weakened the already shaky standing of the throne. The star's growing unpopularity forced her to return to Paris (where she died in 1920), though her on-off relationship with Manuel continued until he married.

However, the most magnificent welcome for the Portuguese royals was offered by a famous dandy, Boni de Castellane, who was married to a wealthy American woman. He organized a lavish party for them in his celebrated Palais Rose, with flaming torches, drums and valets in scarlet livery. The leading European families paraded in, from the Duchess of Vendôme, sporting a diadem of rubies and diamonds, to Granduchess Vladimir of Russia, "armoured" with emeralds. The guests, dazzled by such splendour, could not possibly have imagined that soon afterwards Castellane would be thrown out of that fairy tale setting by his wife, exasperated by his infidelities.

In 1908, an assailant opened fire on the royal family and Amélia tried in vain to hit him with a bunch of flowers and to shield Manuel with her own body, while the seated king breathed his last. When Maria Pia quickly arrived, her daughter-in-law, notwithstanding her pain, realized that the queen mother was suffering more for her grandson than for her son.

When she assumed the regency in the name of her son, Manuel II, the queen seemed to regain the trust of her subjects. "The soul of the dead", she used to say, "illuminates the decisions of the living", but by now the situation was hopeless. In 1910, the young king was astonished to find that the fleet was shelling his palace. The success of the republican coup forced the Braganzas to flee to England on the royal yacht, *Amélia*. They reached it on the boats of Ericeira fishermen, who saluted them ironically by singing revolutionary songs.

After returning to Paris, Amélia began frequenting salons again. Lively and spontaneous, she confided in Abbot Mugnier, the priest most favoured by Parisian high society, that she had made mistakes and needed God's mercy. It was certain, she added, that she would go to purgatory. The queen, Mugnier said, had "all the haloes of misfortune". The French writer, Anna de Noailles, maliciously compared her to the insipid busts of 'Marianne', symbol of the Republic, displayed in many French town halls. "She has a turned up nose, but all the noses of the princesses are well formed". To be sure, she admitted, Amélia had specks of gold in her eyes, but nonetheless she looked like a governess.

The former queen found it hard to understand the profound changes to the social order brought about by the First World War. Upon hearing that a marchioness had shaken the hand of her cook, who had been awarded an important decoration, Amélia could not contain her shock: "But he cannot sit at table near us!" Manuel II, after marrying the pretty but ineffectual Augusta of Hohenzollern-Sigmaringen (1890–1966), died in 1932, far away from Portugal. His burial in the Braganza Pantheon in Lisbon, marked by three days of national mourning, greatly moved Amélia. She had become closer to the dictator Salazar (1889–1970) and, in 1945, the former queen accepted his invitation, though she preferred to make a private visit, to the places associated with her past. When she descended from the train, however, she was applauded by a large crowd and heard cries of "Long live the Queen!", to which Amélia replied: "Not long live the Queen! Long live Portugal!" After returning to France, she resumed her customary quiet life. Though many years had gone by, she continued to ask herself why her husband and son had been assassinated. On her deathbed, she said to her chamberlain: "Don't forget that for my shroud I want the cloak, still stained with blood, which I wore on the day of the attack."

Page 137
Peter Carl Fabergé
Paper knife with case
St. Petersburg, Russia, c. 1900
Nephrite jade, gold, silver, diamonds, rubies
21.2 x 1.4 x 1 cm (paper knife); 2.3 x 23.9 x 4.2 cm (case)
inv. 52207

Page 140
Royal Swam Banner
France, 1750-1761
Silk, gold, silver
57 x 60 cm
MNC, inv. IM0046

Royal Genealogy
of the House of Braganza

D. João IV (1604-1656)
♛ *1640-1656*

D. Luísa
Francisca de Gusmão
(1613-1666)

D. Alfonso VI (1643-1683)
♛ *1656 -1683*

D. Maria Francisca Isabel
de Saboia-Nemours
(1646-1683)

D. Pedro II (1643-1706)
♛ *1683 -1706*

D. Isabel Luísa
Josefa de Bragança
(1669-1690)

Maria Bárbara
de Bragança
(1711-1758)

D. Pedro
de Bragança
(1712-1714)

D. José I
(1714-1777)
♛ *1750-1777*

D. Mariana Vitória
de Bourbon-Espanha
(1728-1781)

D. Maria I
(1734-1816)
♛ *1777-1816*

D. José
(1761-1788)

D. Mariana Vitória
(1768-1788)

D. Maria Leopoldina
de Habsburgo-Lorena
(1797-1826)

D. Pedro IV de Portugal
e I do Brasil
(1798-1834)
♛ *1826*

D. Amélia de Leuchtenberg
(1812-1873)

Maria II
(1819-1853)
♛ *1826-1853*

D. Fernando II
(1816-1885)

D. Pedro II
(1825-1891)

D. Teresa Cristina
de Bourbon
(1822-1889)

D. Estefânia de
Hohenzollern-
-Sigmaringen
(1837-1859)

D. Pedro V
(1837-1861)
♛ *1853-1861*

D. Luis I
(1838-1889)
♛ *1861-1889*

D. Maria Pia de Saboia
(1847-1911)

D. Maria
Amélia de Orleães
(1865-1951)

D. Carlos I
(1863-1908)
♛ *1889-1908*

D. Manuel II
(1888-1932)
♛ *1908-1910*

D. Augusta Vitória de
Hohenzollern-Sigmaringen
(1890-1966)

This book
was printed in Parma
for Franco Maria Ricci Editore
in November 2023